# OIL
# PAINTING
## *Pure and Simple*

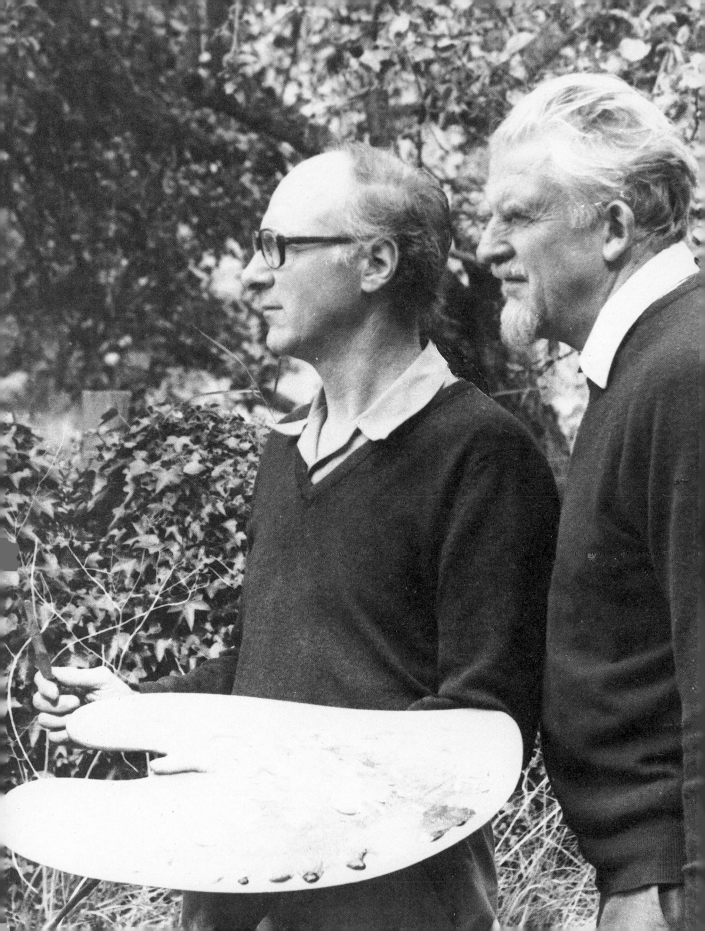

# OIL
# PAINTING
## *Pure and Simple*

**Ron Ranson and Trevor Chamberlain** ROI RSMA

STUDIO VISTA

Studio Vista

an imprint of
Cassell plc
Villiers House
41–47 Strand
London WC2N 5JE

Copyright © Ron Ranson and Trevor Chamberlain 1986

This edition 1992
First published by Blandford Press 1986
Reprinted 1992

Distributed in the United States by
Sterling Publishing Co, Inc,
387 Park Avenue South,
New York, N.Y. 10016-2880

**British Library Cataloguing in Publication Data**

Ranson, Ron
  Oil painting pure and simple.
  1. Painting—Technique
  I. Title    II. Chamberlain, Trevor
  751.45      ND1500

ISBN 0 289 80071 4

Typeset in Lasercomp Plantin by August Filmsetting, Haydock, St Helens
Printed in Hong Kong by Wing King Tong Co. Ltd.

# Acknowledgements

I would like to offer my grateful thanks to Trevor Chamberlain
for agreeing to let me produce this book in the first place. To
Ann Mills for typing the manuscript; to Ray Mitchell for most
of the photographs, with Cyril Nicholson and Clifford Borlaise
producing the remainder; and to Sue Lovett for her invaluable
collaboration over the design of the book.

    Finally, to my patient and understanding wife, Audrey, for
her loyal support and for providing us all with hundreds of cups
of coffee at all hours.

<div align="right">Ron Ranson</div>

# Contents

# Introduction

Basically I'm known as a watercolour artist and teacher, so what on earth am I doing delving into oil painting? Well, some years ago, I produced a book on watercolour which was intended to be a chatty no-nonsense guide to the subject. Having met and taught literally thousands of amateur painters over the years, I felt that I was beginning to understand and perhaps be able to communicate with them in a very much more informal way than most art books do, many of which I find, at times, a little pompous. Thankfully, it immediately became a best-seller in its field. My publisher said, 'Fine, now do one on oil painting.'

After some initial reservations – it was rather like asking a sprinter to run the mile – I thought of Trevor Chamberlain, an artist whose work I had admired for years. His oil paintings were simple and direct, yet capturing the essence of the subject in the manner of the Impressionists, which was basically what I was attempting to do, in my own small way, in watercolour.

I suggested that we might create a book together, illustrated with his paintings, and I would write it, sitting at his shoulder as it were. I went to see him and we immediately established a rapport. Within half an hour we'd agreed.

It was very lucky that I arrived at his house just as he was preparing to mount an exhibition at Clarges Gallery in London and all his canvases were there in rows against the wall. It was like being in Aladdin's Cave, and I immediately reserved three for myself. (I now have nine, so you can see the effect that his work had on me.) I went home full of excitement and determination.

Let me first tell you something about Trevor. He's completely self-taught, having started painting as a hobby when he was twelve. In 1964 he became a full-time professional artist.

One aspect which comes to my mind immediately is that both he and his work are universally respected. His list of achievements is long and his recognition is wide. He's a member of the Royal Institute of Oil Painters, the Royal

'Burn-up on the foreshore', 10 in × 14 in. Painted at Bugsby's Reach on the Thames below Greenwich. The interest is the light and life amongst all the flotsam on the foreshore.

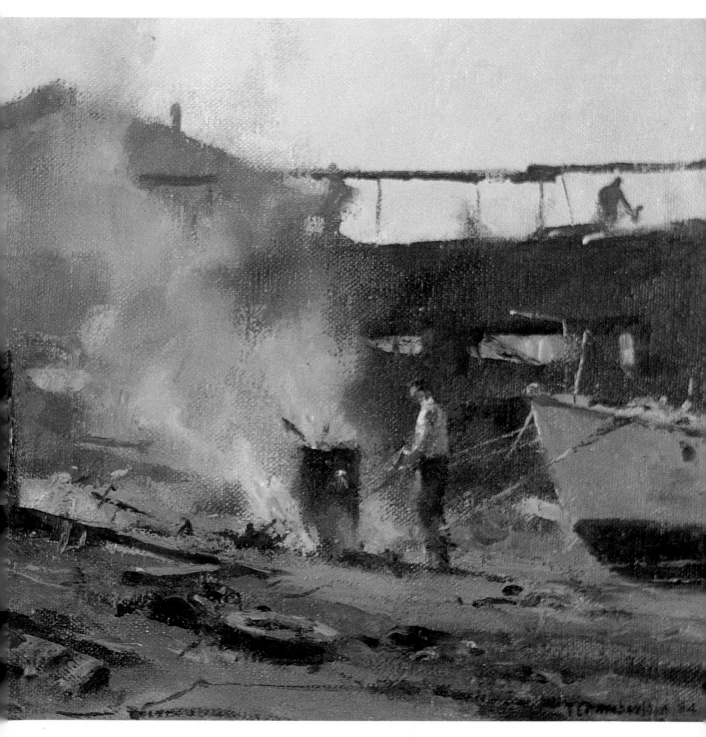

# Introduction

Society of Marine Artists, and a Member of the famous Wapping Group, as well as being President of the Chelsea Art Society. He has won many awards and prizes at prestigious national shows, such as the Stanley Grimm prize at the ROI Exhibition in 1984, the James Bourlet prize at the ROI in 1980, and he was the Lord Mayor of London's Art Award Winner in 1976.

His work is constantly being exhibited in London, including the Royal Academy, and all over the world, but what attracted me to him in the first place and sent me to his door was not the awards but the fact that he painted in oils in a style that many thousands of amateur artists would give their ears to be able to emulate. I believe that this collection of his paintings and perhaps to a lesser extent, my descriptions of his methods, will inspire countless people to go out to brave the elements and paint in the open air to capture the essence of the scene in front of them.

Just looking at his work makes my mouth water, and I immediately want to rush out and emulate him, just as ten years ago, I saw the work of another artist, Edward Seago, whose watercolours so inspired me that they virtually changed my life and started me on a new and much happier career as an artist at fifty after spending most of my life in factories and offices.

Take the subject matter of Trevor's paintings in this book. There are very few 'pretty' pictures here. He finds his inspiration in such ordinary things as a man burning rubbish on a beach, a bus garage, or a Liverpool street in the pouring rain. Many of us would dismiss these as subjects without a second glance, but just look at what he's done with them.

Michael Shepherd, art critic of the *Sunday Telegraph* wrote 'The work of Trevor Chamberlain has shone out for me with its remarkable liveliness of almost breathable air and flickering light. Anyone who dotes on Boudin may feel a kindred spirit here. He is one of the finest exemplars of the merits of working from life in the open air.'

If I stopped writing at this point, it wouldn't matter much. Trevor's paintings would speak for themselves.

*Ron Ranson*

# Materials

You can often tell the professionals from the amateurs by the amount of equipment they carry around with them, even before they start to paint. The beginner gets trapped into buying all sorts of unnecessary gadgets in the art shops, somehow thinking they they are going to be able to solve all their problems, and they end up by dragging them all around the countryside. The reverse is the truth, especially when you're working mostly out in the open as Trevor Chamberlain does. Reducing equipment to the bare necessities is essential when one has to tramp or wade to inaccessible vantage points or cope with changeable weather.

**The Paint Box**
This is made of zinc and is 14 in × 10 in × 3 in. It holds brushes, palette knife and dipper, a small bottle of turpentine, rags, colour tubes, gel medium, willow charcoal, a length of cord, soft pencil, pen-knife and a small sketch book. In the lid of the box he has a 14 in × 10 in canvas, the face of which is held clear by four small pieces of cork, an eighth of an inch thick, stuck at the corners of the lid to protect the wet painting.

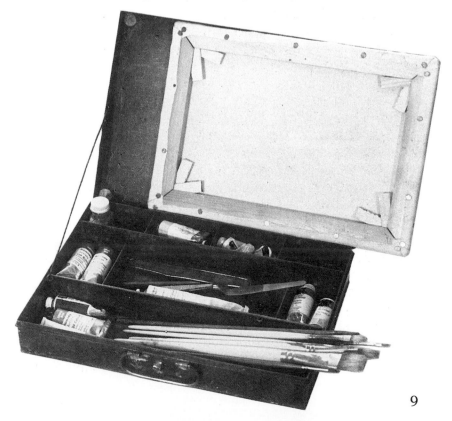

Trevor Chamberlain's paint box with its 14 in × 10 in canvas in the lid.

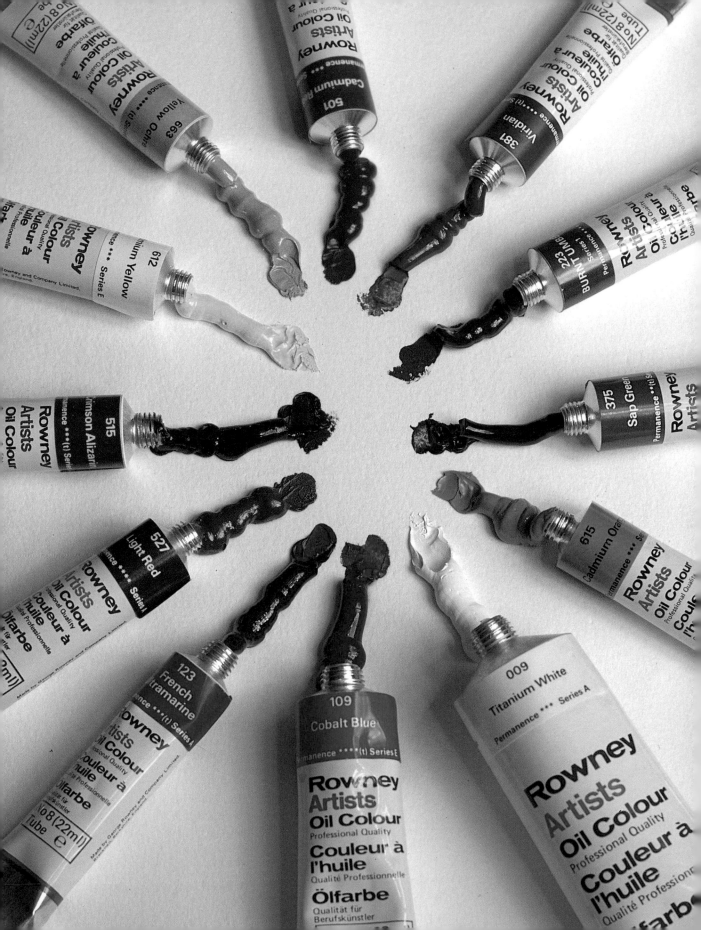

*Opposite*: Trevor Chamberlain's complete selection of colours.

## The Colours

Again, amateurs usually load themselves down with far too many tubes of paint. Trevor uses a restricted, uncomplicated palette.

Let's look at his main colours, one by one:

1   *Titanium White* – this has good covering power and is very opaque.

2   *Yellow Ochre* – this is a natural earth colour, a dull yellow or tan, and is useful in all landscape work. Mixed with the blue this also produces greens.

3   *Cadmium Orange* – mixed with blue and white this produces a variety of warm and cool greys, and also makes good, deep greens.

4   *Light Red* – another very useful colour with a hint of orange in it.

5   *Viridian Green* – this is very valuable, but one that must be used with discretion.

6   *Cobalt* – this is a very beautiful, very delicate blue which is very handy for skies.

7   *Ultramarine* – this is a dark subuded blue with a faint hint of violet, and it is a very good mixer.

8   *Burnt Umber* – a dark, rich, warm brown; it's a rapid dryer. A little added to white speeds up the drying of the whole picture. Also if it's mixed with ultramarine it's good for dark darks!

He also uses small quantities of these colours when required:

9   *Cadmium Yellow* – this is a very bright opaque yellow, useful for mixing greens and painting sunlit areas.

10   *Alizarin Crimson* – a dark red with a slightly violet cast, although very transparent, this colour stains and dominates other colours, so watch it, use only a little at a time.

11   *Cadmium Red* – a bright red which must be used with discretion.

12   *Sap Green* – this is useful for under-painting and is used in small patches.

That makes twelve colours in all, and covers all his needs.

*Below*: The Rowney's Gel Medium which halves the normal drying time of the paint.

You'll see that there's no black in his palette, Trevor feels that as a landscape painter the use of black as an oil pigment has an incongruous and deadening effect when intermixed.

While we are on the subject of colour, I must mention the meanness that comes over most students when they get a tube of colour in their hand. They put a tiny blob of colour on their palettes, and instantly put the tube back in their box! It happens in all my classes, and it's known in the trade as a 'starved palette'. You will never achieve rich oil paintings, unless you learn the joy of being generous with the paint, so that the surface of your painting has a patina of pigment as you work one colour into, or over another.

*Above*: Willow charcoal used for the preliminary drawing on the canvas.

*Below*: The large long-haired bristle brush used for the blocking in of the painting.

## Gel-Medium

Trevor seems to avoid the rather bewildering range of liquid mediums and oils available, instead he relies only on a tube of Rowneys Gel Medium to mix with his oil colours. It's a safe, fast-drying, synthetic resin and standard oil medium which halves the normal drying time of the paint.

He squeezes it out on the palette like another colour, first pre-mixing it with the white, and then leaving another blob to add to his subsequent colour mixes.

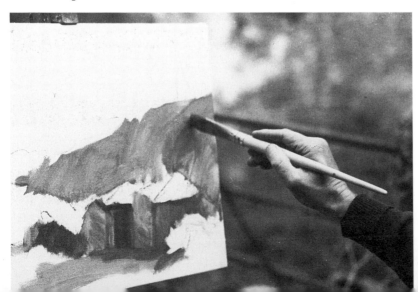

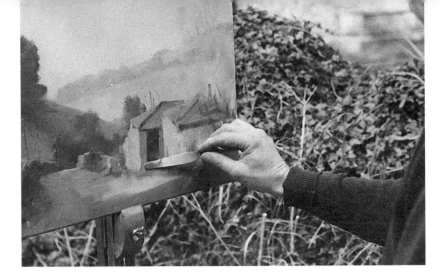

## The Palette Knife

He has one knife which he uses for the mixing of paint on the palette and a great deal of its application on the canvas. I'd say that almost half his painting is done with it. He rather scorns the specialised painting knives with their little trowel shapes as being too 'fiddly', but he manages to make very delicate strokes with the side of his knife for such things as ships masts, gutters on buildings, as well as using it for very bold applications of skies, etc. The most important thing that he stresses is that the technique itself should never dominate the painting and become mannered, which often happens with crude impasto – the subject itself must be all-important. He tends to soften off many of his knife strokes with a judicious finger. He also uses the knife for scraping off 'muddy' or overworked passages.

## Brushes

These are again cut down to the essentials. It's pointless to carry around more brushes than you actually need. First a large number 10 flat, long-haired bristle brush which is used for the preliminary blocking in of the painting. It covers large areas of the canvas quickly and establishes the basic colours and their tonal

*Above*: The palette knife used for mixing paint on the palette and much of its application on the canvas. Being cranked, it keeps the knuckles away from the wet canvas.

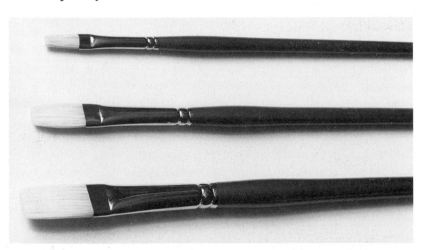

*Right*: The three bristle brushes for general painting.

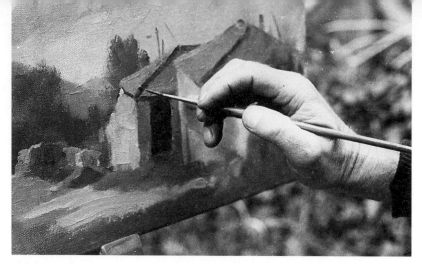

relationships. He then uses about three bristle brushes in sizes 3, 5 and 7 for the general painting. Finally, a fine sable rigger for such details as branches, figures, etc.

### The Palette

Trevor uses a traditional mahogany, kidney-shaped palette, about two feet long. It has been used and cleaned daily for so many years that it's developed a deep fine gloss, which must be a joy to mix colour on.

### The Canvas

Trevor prefers a canvas with medium tooth, as they provide a very sympathetic texture for use with brush and palette knife. These he prepares himself by putting together the bought stretcher pieces and using 9 oz cotton duck. He trims the unprepared canvas so that it measures 2 in larger than the finished size. Then, using $\frac{3}{8}$ in tin-tacks, he knocks in four tacks initially to hold the canvas in place. These are placed in the centre of each edge. Working from the centre outwards, he puts in more tacks to the stretcher edges, 4–5 ins apart, firmly pulling outwards and towards the corners.

He then places the canvas face downwards and, by careful pulling and folding, he fixes each formed corner securely to the back of the stretchers using two tacks. The canvas edge is then tacked to the back of the stretchers by pulling on the canvas and fixing more tacks in staggered positions between the ones which are already positioned on the edges. The canvas should now be fairly taut but unprimed.

To the canvas face he applies a good coat of white acrylic primer, followed when dry by a second coat. When this is dry he lightly sandpapers off the rough spots and puts on a third coat of acrylic primer. He then taps in the wedges and allows the support to mature for several weeks.

If you want to take off the whiteness of the canvas, which is a bit formidable for some painters, just put a thin transport tint of the appropriate acrylic paint, say Burnt Umber in your last coat.

*Above*: The fine sable rigger used for details – don't be tempted to over use this!

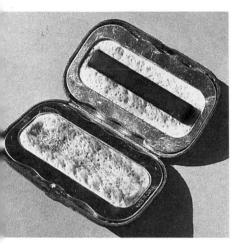

*Above*: The hand-warmer shown open, with its stick of charcoal.

To enable him to cope with a subject in a limited time, he restricts himself to small canvases – 14 in × 10 in and 20 in × 16 in.

### The Easel
This is a traditional folding wooden easel, shown below. In windy conditions he suspends on a cord any heavy object he finds on site, such as a brick, under the easel to hold it down. There is nothing more annoying than to have one's easel blow over when you've got a wet canvas, especially when it always seems to fall 'butter side' down!

### Winter Warmth
Working as he does in the open in the middle of winter, he does, of course, have to wrap up well with warm protective clothing, but here are a couple of ideas. First he wears open palmed, fleece-lined shooting mittens which keep the hands fairly warm, but give him the freedom he needs for use of his fingers.

The second is an idea borrowed from anglers; it's a novel pocket hand warmer which can be bought from any angling shop and is shown left. The active element is a stick of charcoal which is lit at one end, and when really glowing is placed in the centre of the warmer and the lid closed. It then provides a good warmth for many hours.

*Right*: Trevor at work showing the wooden easel and his large kidney-shaped palette.

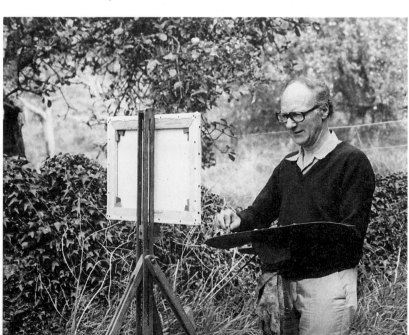

# Pochade Box

I've decided to devote a whole chapter to this because I believe it might open up a whole new exciting field for many would-be painters who have previously been put off by all the apparent clutter and formality of oil painting equipment. Also, one perhaps feels a little vulnerable and conspicuous standing out in the open with an easel, where one often seems to attract hordes of chatty, casual observers like wasps round a honey-pot.

A Pochade box is actually a very old fashioned nineteenth-century device which vanished completely from the scene. Perhaps this book will help bring it back again, and show some of its advantages. The particular box which you see opposite has rather a tragic history. It was originally owned by Peter Gilman, a professional artist who often used to paint with Trevor and who shared his love of braving the elements and working on the spot all the year round. Sadly however, some time ago, Peter took his own life and left his Pochade box to Trevor, who now uses it regularly and produces quite a large portion of his output with it, particularly since this book was envisaged.

The pictures shown in this chapter and others elsewhere in this book with dimensions of 6 in × 8 in are produced with this box.

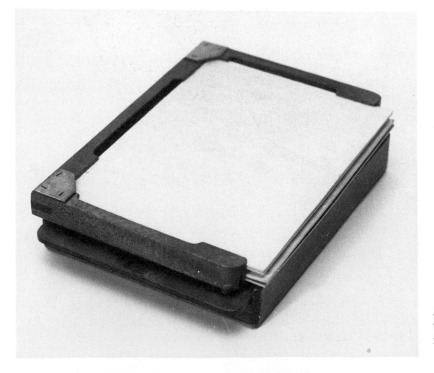

*Left*: The box shown closed with the prepared boards facing inwards.

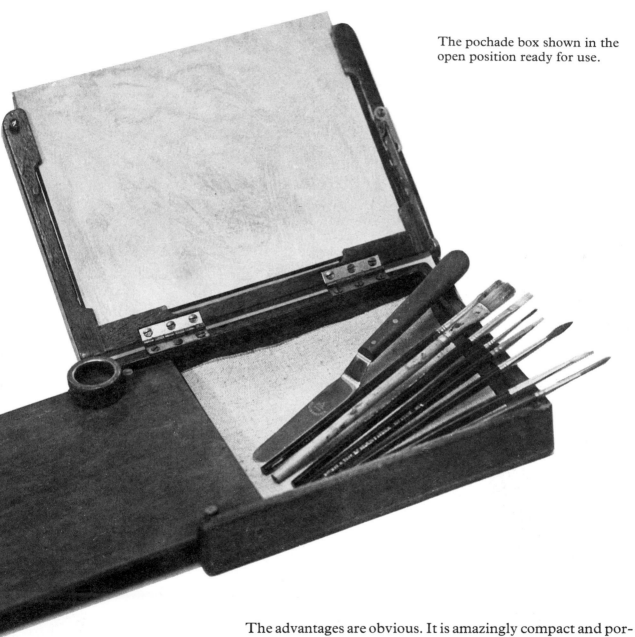

The pochade box shown in the open position ready for use.

The advantages are obvious. It is amazingly compact and portable and very unobtrusive and, of course, you don't require an easel, so you can paint in quite busy locations without attracting much more attention than if you had a camera. You can use it standing or sitting and tucked away in a confined corner. This is especially useful for such subjects as busy street scenes or church or station interiors.

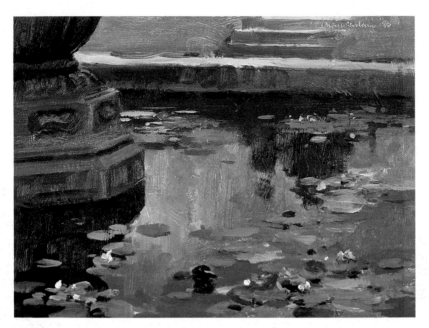

*Left*: 'Lily Pond', 6 in × 8 in. Here, he rather liked the pattern of the lilies seen on the surface of the pond against the reflected sky.

*Below*: 'Poplars on the Marsh', 6 in × 8 in. Painted about 100 yards from his home, the beautiful warm colours of the trees in the afternoon light contrasting against the cold snow.

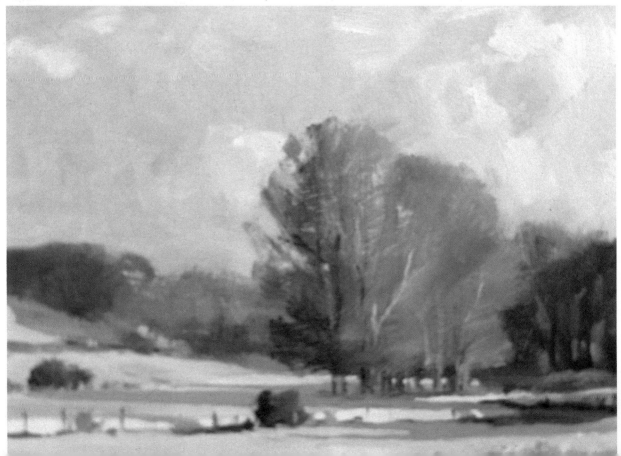

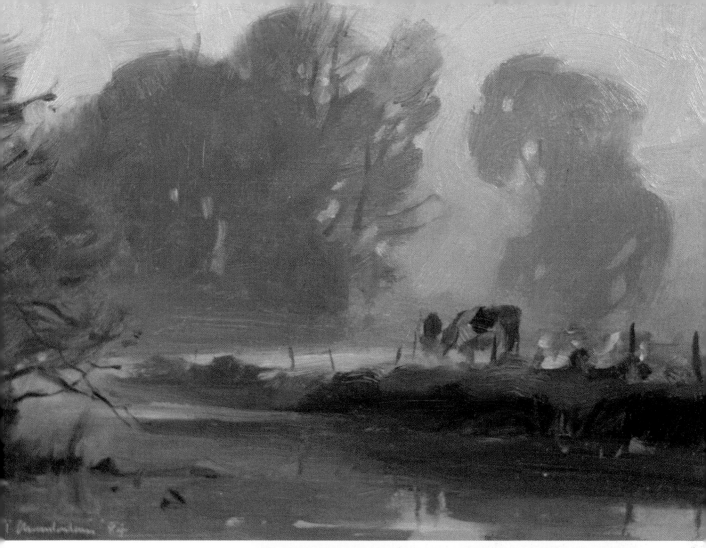

*Above*: 'November – Goldings Marsh', 6 in × 8 in. There was no direct light here but a general quiet warm tone suffused the whole scene.

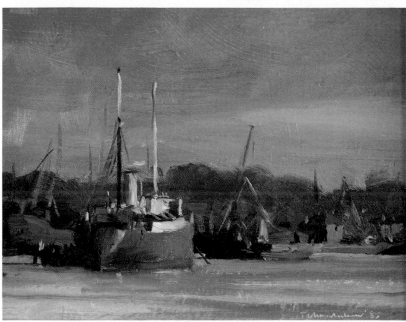

*Right*: 'Low evening light Greenwich', 6 in × 8 in. Warm passages of light and colour were picked up by the setting sun.

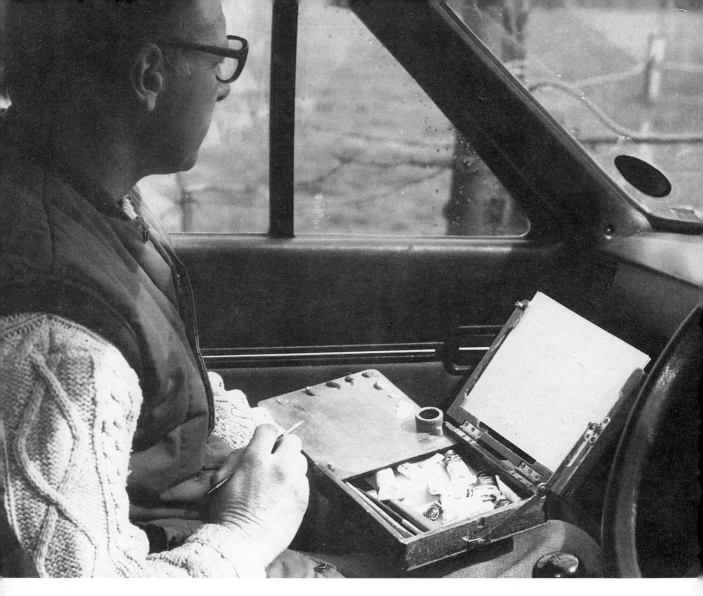

It's in a car that the Pochade really comes into its own. It makes it possible to sit comfortably in the front passenger seat in any type of weather throughout the year and paint in comfort without any disturbing influences, human or otherwise.

What of the results? Although the surface Trevor uses is just prepared mounting board, there is no need to regard them merely as oil sketches. The one on this page, for instance, was accepted for the RA, but unfortunately not hung for the Summer Exhibiton in 1985 – I'm pleased to say that I now own it.

A glance at the paintings in this chapter will show that they stand comparison with the larger works. Well framed, they may even sell more readily and certainly look perfectly at home on the walls of a gallery.

Now to the box itself. The one illustrated measures about 10 in × 7 in × 3 in and can be held in one hand. It has its own built-in palette. The hinged lid contains three 6 in × 8 in pre-

*Above*: Trevor about to start work on a painting in the passenger seat of his car in the rain.

20

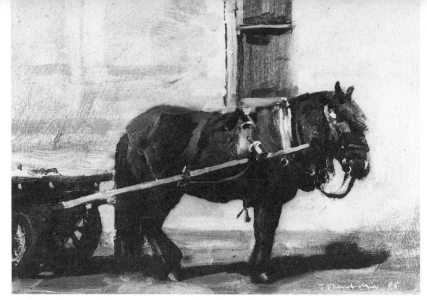

*Right*: 'Totters Nag', 6 in × 8 in. Trevor suddenly came round the corner and there was this little horse and cart. He sat down at the edge of the road and painted it in forty minutes, while the owner was in a pub opposite.

*Left*: View showing the thumb hole in the base of the box.

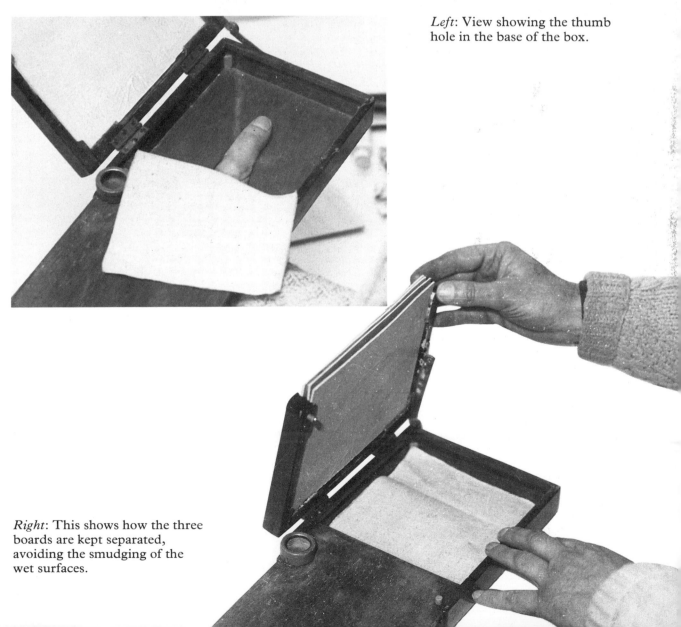

*Right*: This shows how the three boards are kept separated, avoiding the smudging of the wet surfaces.

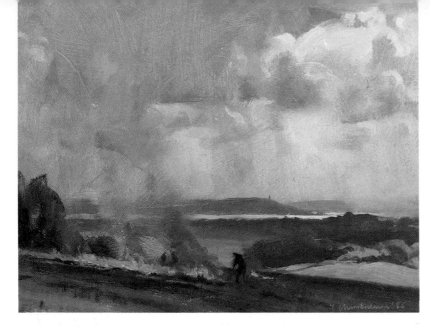

*Left*: 'Stubble-burning above the Humber', 6 in × 8 in. Driving past this scene in Yorkshire, he turned back, attracted by the fire, and painted the scene from the car. He also liked the atmospheric distance.

*Below*: 'Afternoon – Santa Maria Della Salute', 6 in × 8 in. One of the very few paintings in this book not done on the spot but worked from a sketch and memory.

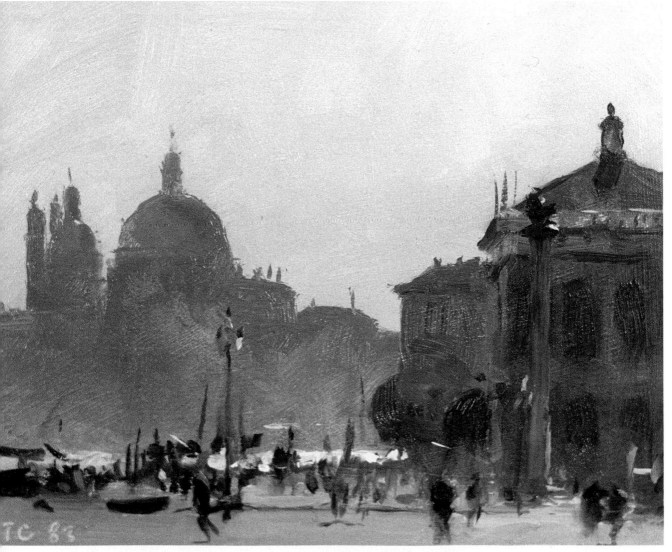

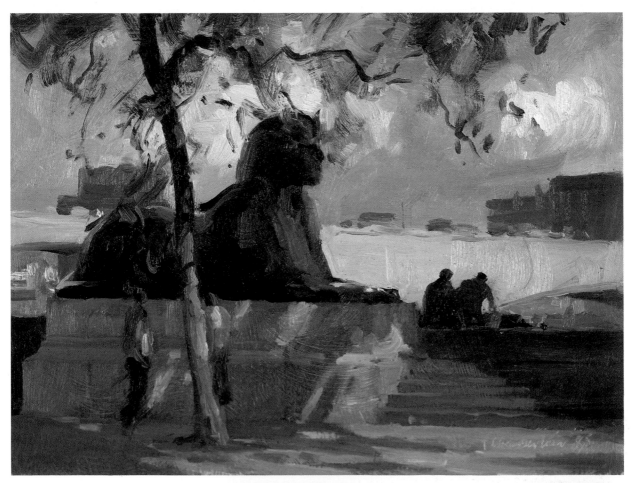

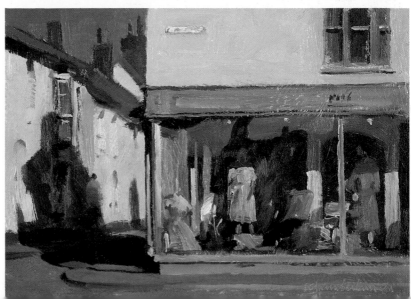

*Above*: 'The Sphinx – Victoria Embankment', 6 in × 8 in. The shape thrown up by the lighting effect. Notice the dramatic counterchange of the two figures against Waterloo Bridge in the distance.

*Right*: 'Avrils', 6 in × 8 in. This was painted with the pochade box, sitting in his car. He liked the patterns and colours of the dresses in the shop window, together with the reflections on the glass. The shadows on the left counterbalance the picture.

*Above*: 'Sweeping-up –
Spitalfields Market', 6 in × 8 in.
On the face of it an unattractive
scene – rubbish on a grey day,
but there was the challenge of
making a painting out of an
unlikely subject.

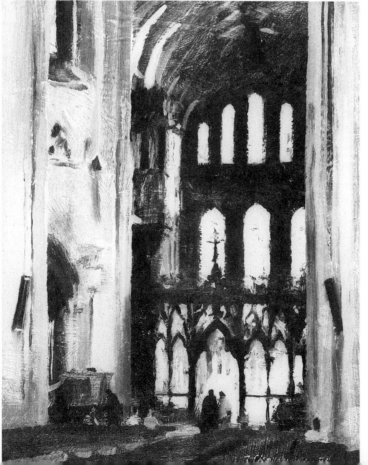

*Left*: 'Interior – Ely Cathedral',
8 in × 6 in. Very subtle lighting
effect here with plenty of
contrast. Trevor asked
permission first.

pared boards, and when open it's set at a suitable angle for painting. The palette slides out at the side to leave the contents readily available. A few colours in small tubes from the following list are perfectly adequate: Titanium White, Yellow Ochre, Cadmium Yellow, Veridian, Cadmium Red, Alazarin Crimson, Light Red, French Ultramarine, Burnt Umber and Sap Green, together with a tube of gel. You'll need about three or four brushes, with handles cut down to fit in the box, a tiny bottle of turps, a dipper, a palette knife and a rag. At the bottom of the box is a thumb hole suitably positioned for balance.

As all the painted surfaces are kept apart, you can close the box with confidence, knowing that the three wet paintings you have just produced will not smudge on the way home. You can even leave the paint on the palette while you are travelling between venues. The Pochade box will also fit easily into a carrier bag or rest comfortably on the rear sill of your car. Of course, because these boxes are so convenient, it might be easy to forget such important necessities as washing your brushes afterwards when you get home with soap and water.

But how can you get hold of one of these boxes? As I said before they have pretty well disappeared from the market now, but you may be lucky enough to find one in a second-hand shop, or you might be able to make one yourself, or get a friendly local handyman to make one up for you from the photographs in this book. If all else fails you can obtain one from my local framers, Beavers of Monk Street, Monmouth, who have now decided to make them in small numbers.

Now to the preparation of the actual boards themselves. The process is relatively cheap. Just go out and buy some reasonably thick mounting board and then cut it down to size with a Stanley knife making sure the resulting pieces fit the distance between the slots in the lid accurately. Next, mix some acrylic primer with some textured paste in a saucer and paint two coats onto the mounting board. Textured paste gives it quite a good sympathetic tooth to work on. When this is dry put a weak, light, wash of acrylic Burnt Sienna on it to kill the whiteness and you're ready for action.

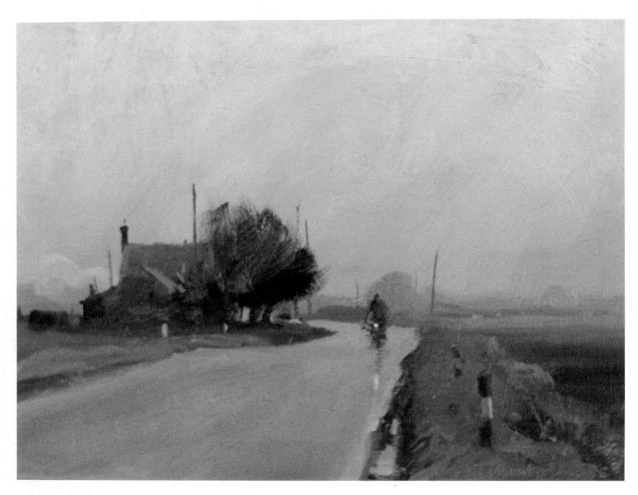

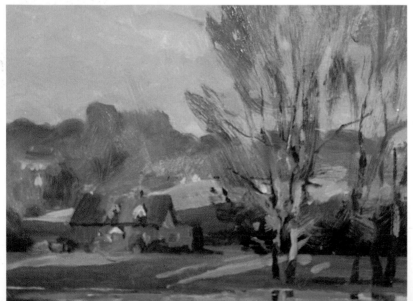

*Above*: 'Rain in the Fens', 6 in × 8 in. Painted in the car in the driving rain near Wisbech. He was first stopped by the grouping of the house and tree against the bleak landscape.

*Left*: 'Autumn Evening, Waterford Marsh', 6 in × 8 in. This had to be painted within the matter of an hour as the warm autumn afternoon light soon faded. Note how the paint is applied directly with no fussing.

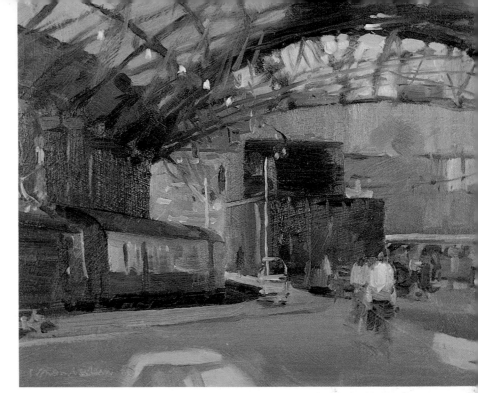

*Right*: 'Lime Street Station, Liverpool' 6 in × 9 in. The attraction here was the sweep of the station roof with the colours enhanced by the evening light.

*Below*: 'North Wales Beach', 6 in × 8 in. There was a combination of colours, figures, and the headland in the distance echoing the boulders in the foreground. Note how the shadow across the foreground emphasises the sunlit beach.

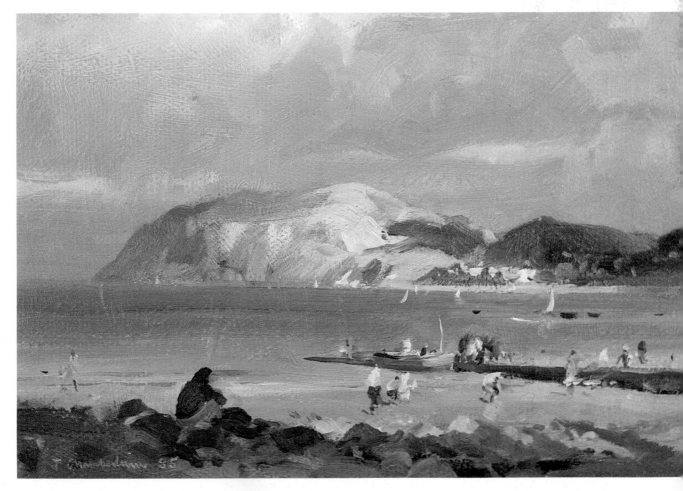

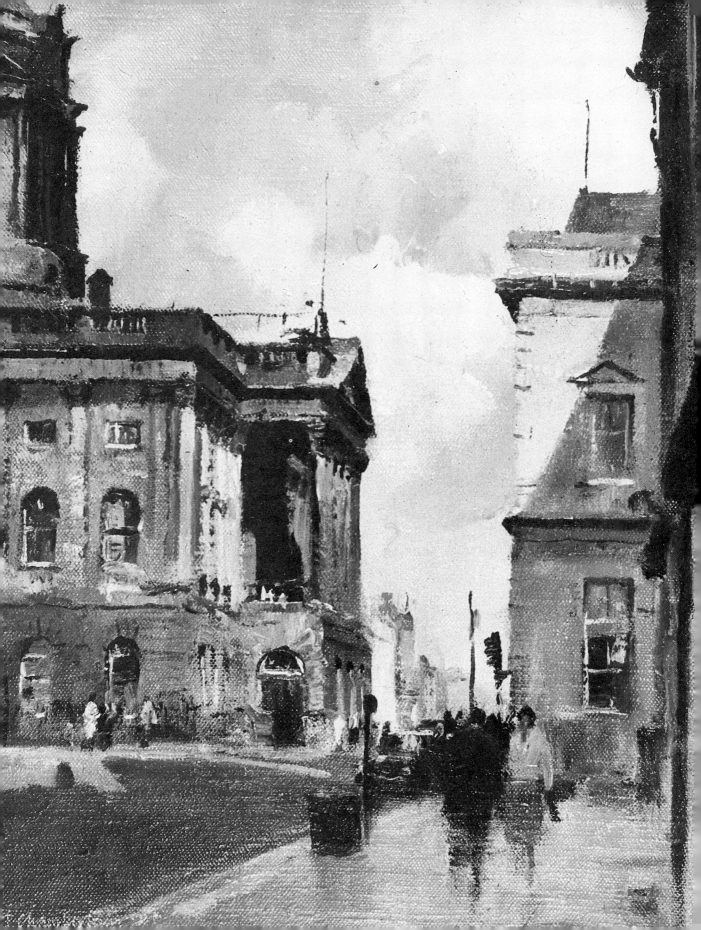

# Townscapes

*Opposite*: 'Liverpool Town Hall', 14 in × 10 in, painted on a Sunday. Apart from the lighting effect he was interested in the architecture and the feeling of reflected light in the foreground shadows. The figures give it scale and life.

*Below*: 'Summer Light, Pump Court, Middle Temple', 6 in × 8 in. The light was bouncing off in all directions within the enclosed court and there was a view through the arches to the street beyond.

Trevor Chamberlain's overriding belief is that to paint convincing pictures which convey subtle feelings of mood, atmosphere, light, tone and colour, one must be prepared to suffer the rigours of the prevailing climatic conditions, and just be there, experiencing these sensations at first hand. Of course, it often means enduring (and ignoring) the distractions of a busy street. He feels that for him it would be useless to make a furtive sketch through a car window and then hurry back to the studio to try and recall the transient feelings and subtleties of the spot. So, whenever possible, once having selected his subject, he works in one sitting, on the spot for a maximum of three hours, or less (especially in the winter), working with enormous concentration to make an immediate, spontaneous statement.

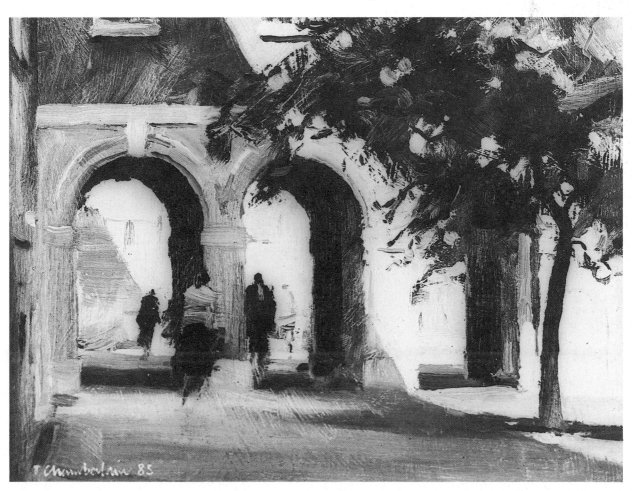

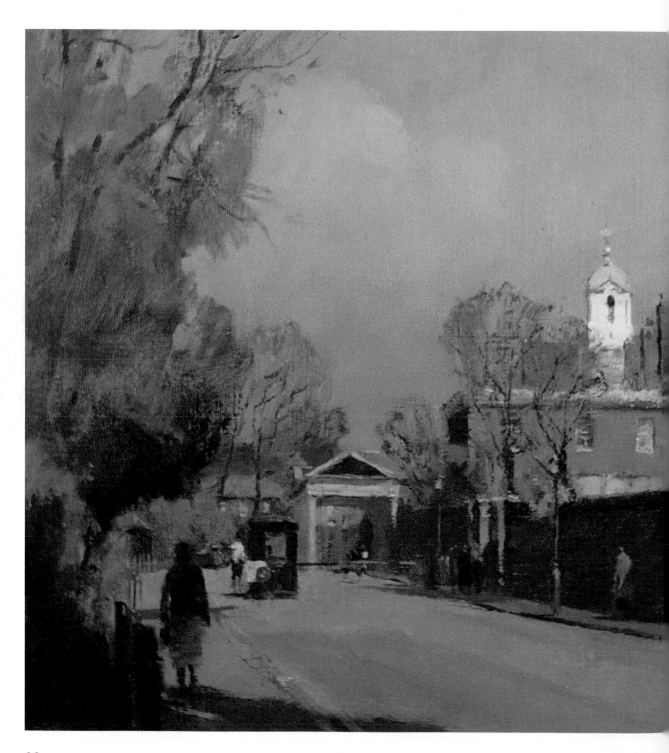

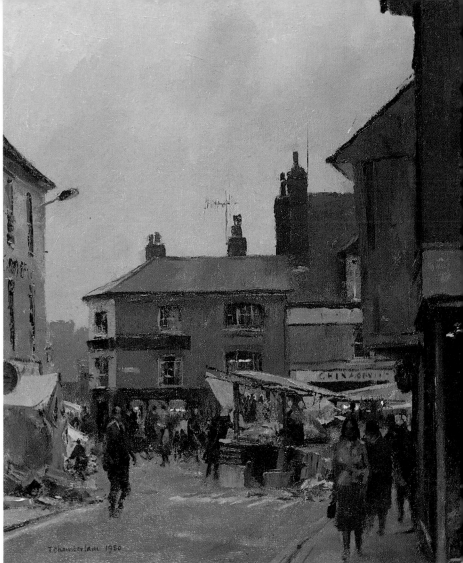

*Left*: 'Kensington Palace –
Spring 1984'. He was attracted
by the brilliant light on the clock
tower. The rich, warm colour of
the sunlit brickwork, contrasted
with the shadowed wall.

*Above*: 'Hertford Street Market',
20 in × 16 in. A street scene
seething with life, suggested
without too much detail. It was
a dull day, but there was plenty
of local colour.

He then goes back to the studio to do another hour's work on
it. During this time he considers it very critically and makes any
refinements before he deems it finished. Take the 'Demolition
of the Steam Packet', on page 44. This was done in Lower
Thames Street in the City and was basically produced in 3½
hours, even though it involved much architectural detail and
plenty of activity going on all around.

He hardly ever believes in painting beyond this time or going
back another day. No two days are ever the same because of the
changing light and different circumstances.

Incidentally, most of us would normally think of painting a

31

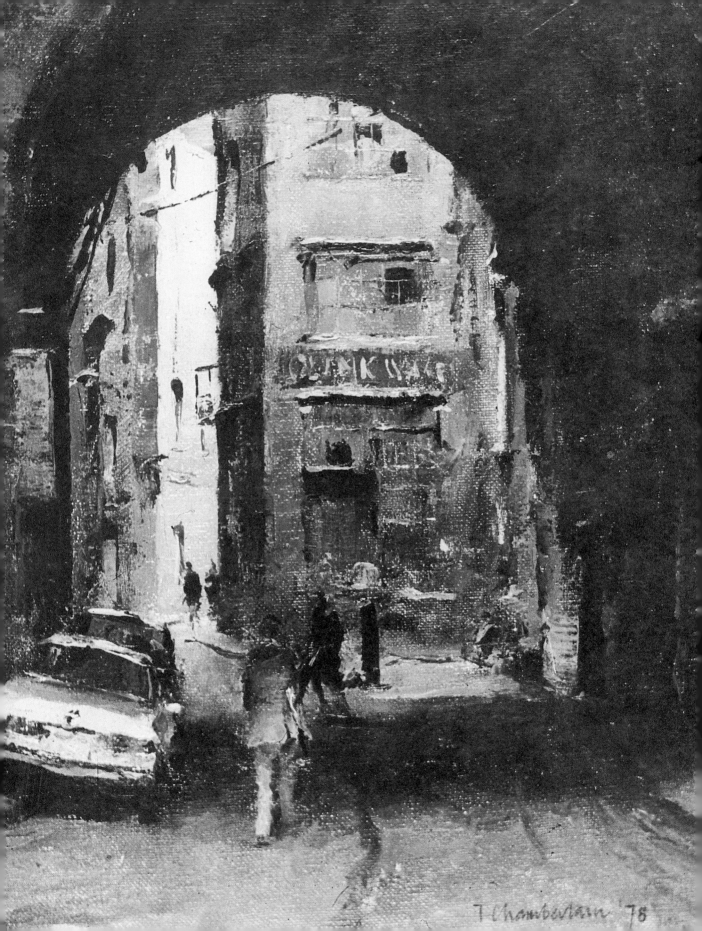

*Opposite*: 'Entrance to Clink Wharf', 14 in × 10 in. What interested him here was the decrepit old building framed within the strong arch shape. The white car is quite important in the design of the picture.

*Below*: 'A damp, foggy day in December', 10 in × 14. A penetratingly damp day with no light, giving lots of opportunities of aerial perspective. Notice how he avoids putting the lorry dead centre.

pub in an attractive setting. Trevor, being different, decides to paint one being demolished, but I bet what attracted him to it was the play of light on the inevitable clouds of dust.

Look at the painting, on pages 42/43, of a Liverpool street. The title says it all – 'It Rained All Day'. I can just imagine Trevor crouching in a doorway under an umbrella, working with the rain trickling down his neck.

The whole painting is a symphony of greys with just the contrast of bright colour in the traffic lights, full of the atmosphere of the place. (I know, I spent my childhood in Liverpool.) One can't imagine anyone producing that painting at home in a warm studio.

Your paintings of street scenes, will, of course, contain houses. So it's probably as good a time as ever to introduce linear perspective. The very words themselves seem to strike

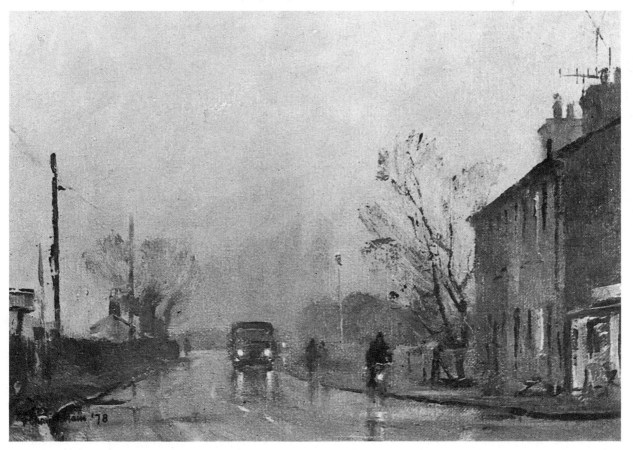

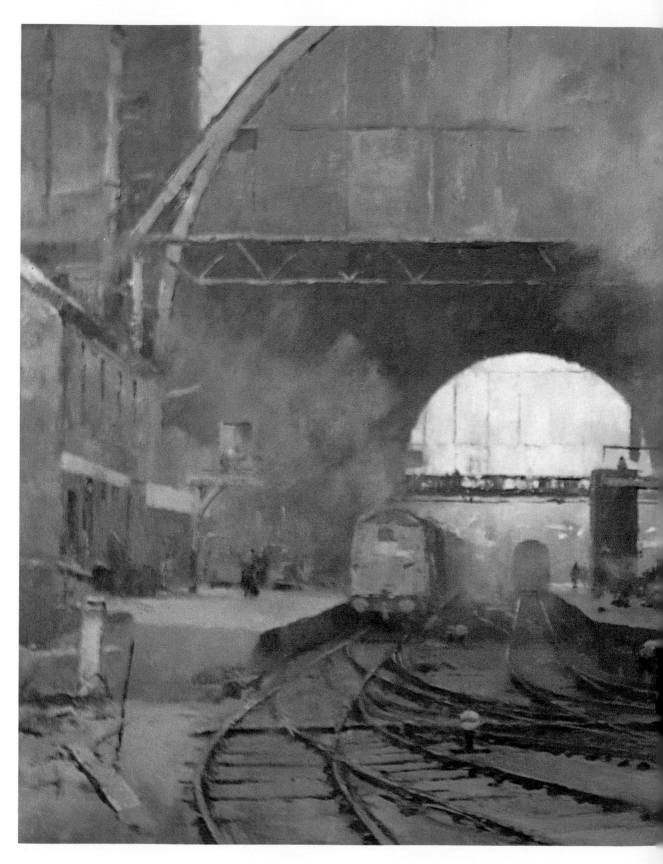

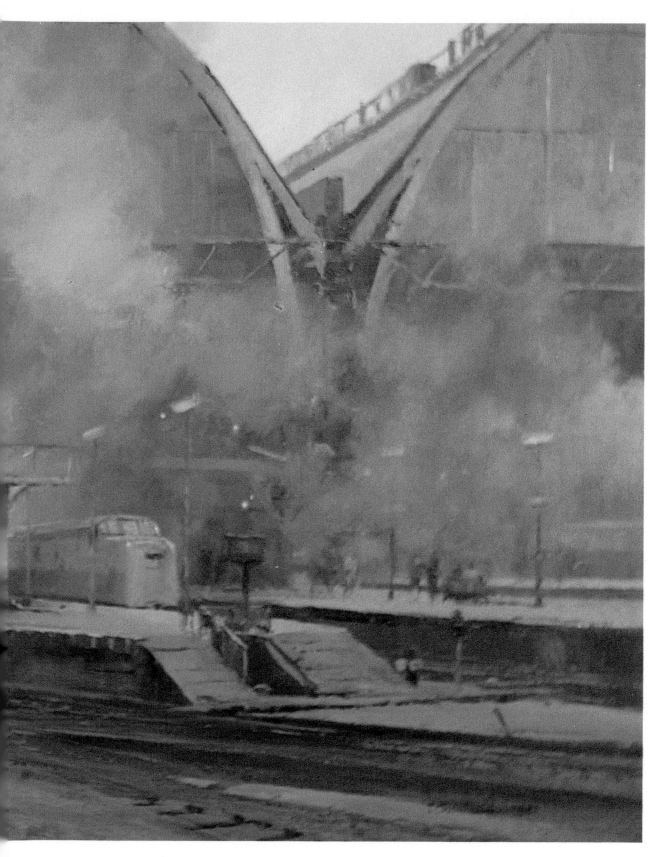

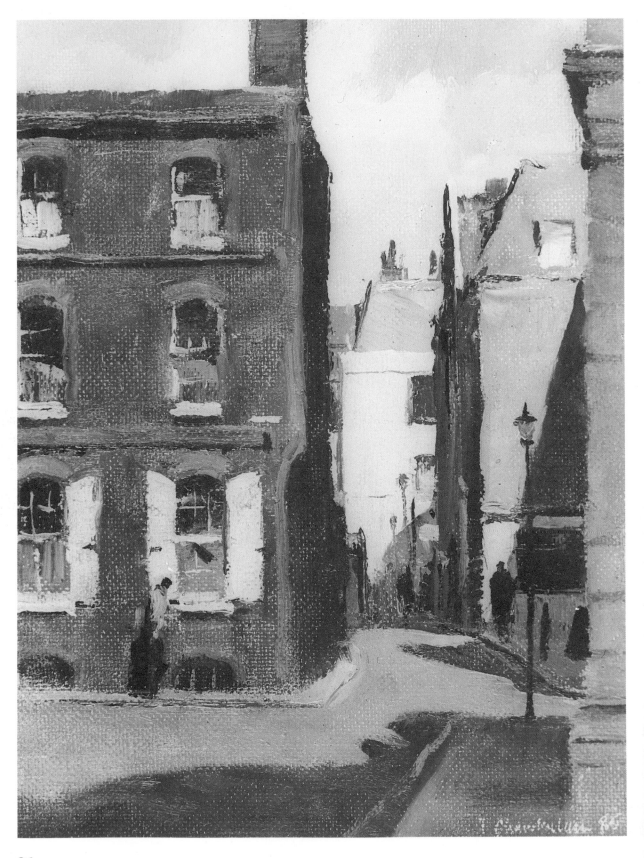

*Opposite*: 'Corner of Carey Street', 10 in × 7 in. Here there is a contrast of textures of different buildings, brickwork, stucco and stone, together with the effect of the shadows.

*Previous spread*: 'Diesel smoke, King's Cross Station', 20 in × 36 in. A painting done from a smaller one on the spot. Note the effect of the warm, yellow light seen through the murky smoke.

*Below*: 'Busy morning on the Grand Canal', 12 in × 16 in. He was attracted by the architecture of the fish market on the right and the bustle of the waterway.

terror into so many of my own students, perhaps it's no wonder when they hear such terms bandied about as 'multiple vanishing points', and 'conical projection'. Well, just forget them, all that is necessary for a landscape painter to have, is a sense of perspective and an eye for the obvious. Just remember these simple rules, (which you'll probably know anyway). First, objects in a landscape appear to diminish in size as they recede from the viewer. Second, the horizon is always at the eye-level of the viewer. Third, parallel lines on such things as buildings tend to

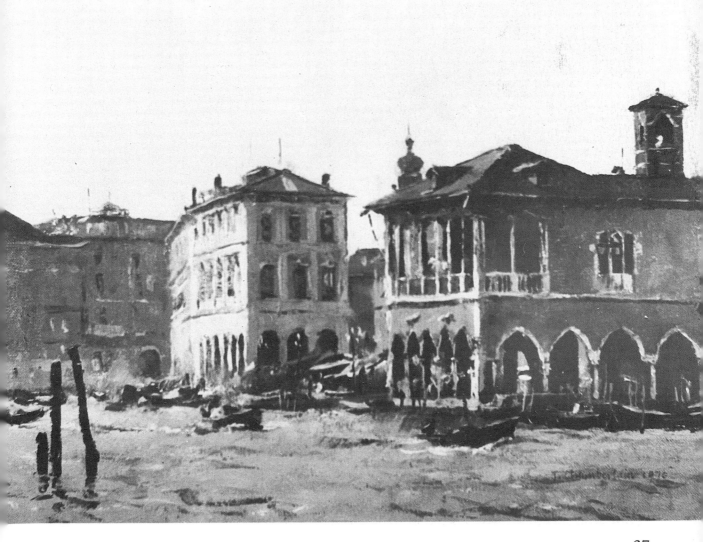

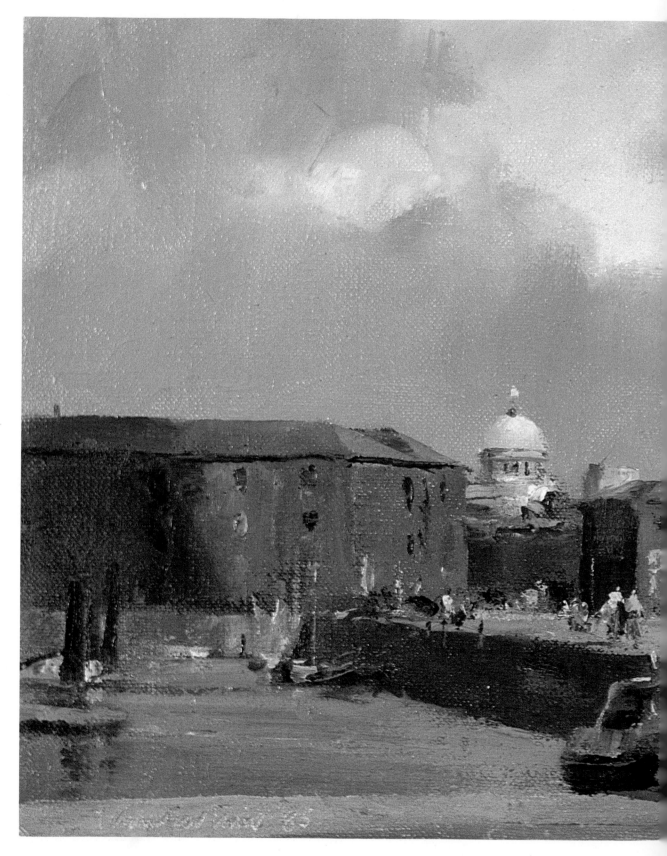

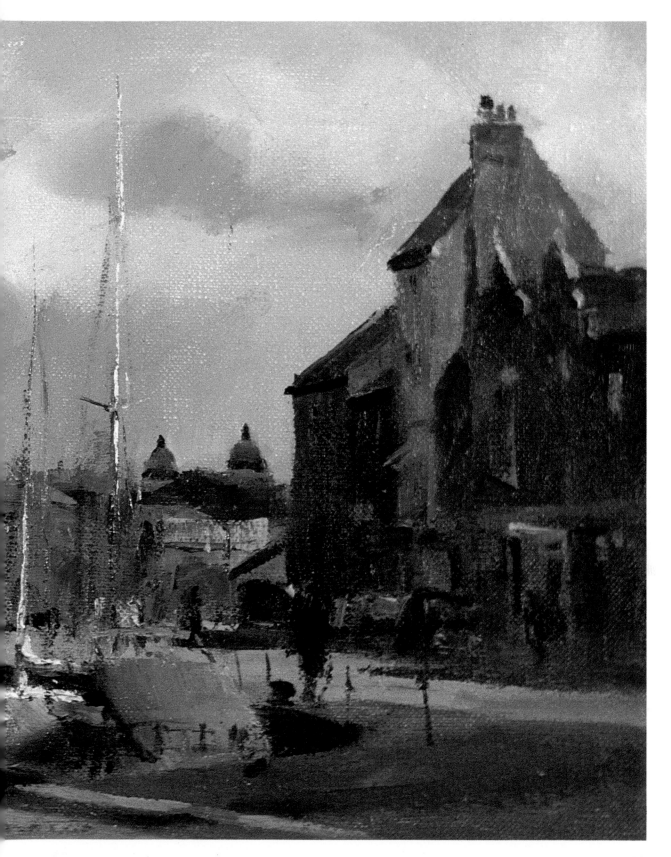

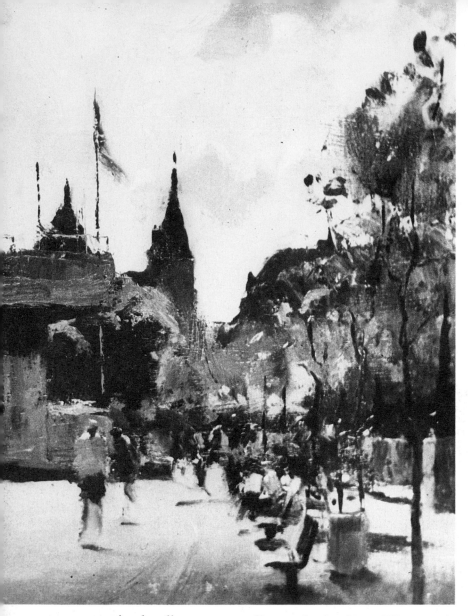

*Left*: 'Afternoon, South Bank', 8 in × 6 in. It was a beautiful, bright day in July with interesting cloud formations and people and buildings seen in silhouette against the light.

converge in the distance, usually on the horizon. The rest is mainly common sense and observation. Whole books have been written about the laws of perspective but as with legal laws, you need only enough knowledge of them to be able to keep out of trouble.

Try to make a good abstract pattern in your street scenes, choose a few big main shapes, and arrange them well in your picture space. Do this before you think about details or about what the objects actually are. What time of day you paint your street scene is up to you, of course, but long shadows which are created in early morning and late afternoon are a great help in establishing an abstract pattern. Organise the areas of light and shade and use them as part of your picture composition.

You'll learn a lot about the painting of good townscapes by studying the works of such Masters as Turner and Bonington,

*Previous spread*: 'A quayside at Hull', 10 in × 14 in. The design looked right from the start, with very little needing to be changed. He liked the architecture of the quay-side warehouses and the hint of the grand buildings in the distance.

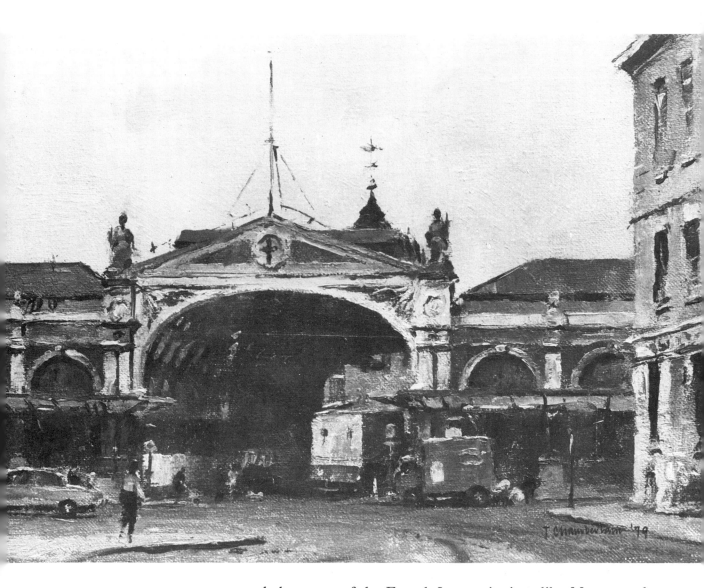

*Above*: 'Royal Mail – Smithfield Market', 10 in × 14 in. He was interested in the strong architecture of the building which he portrayed without detail and also the dark tunnel shape with a hint of unknown things going on.

and also many of the French Impressionists, like Monet, and Pissaro. Study them carefully and notice their simplification of detail. Try to develop a painter's shorthand that suggests rather than copies the detail found in street subjects. For example, if a house has shutters, put them in with a single brush stroke, there's no need to paint the individual slats. Try to make a personal statement, remember, it's not what you paint, but how you paint it that will make your painting interesting, so let your brushwork be as personal as your handwriting.

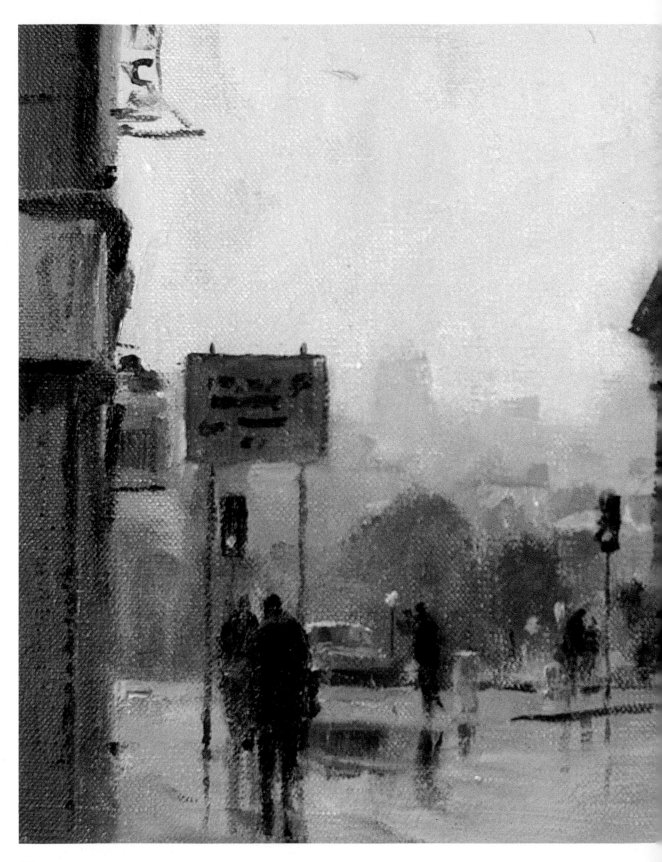

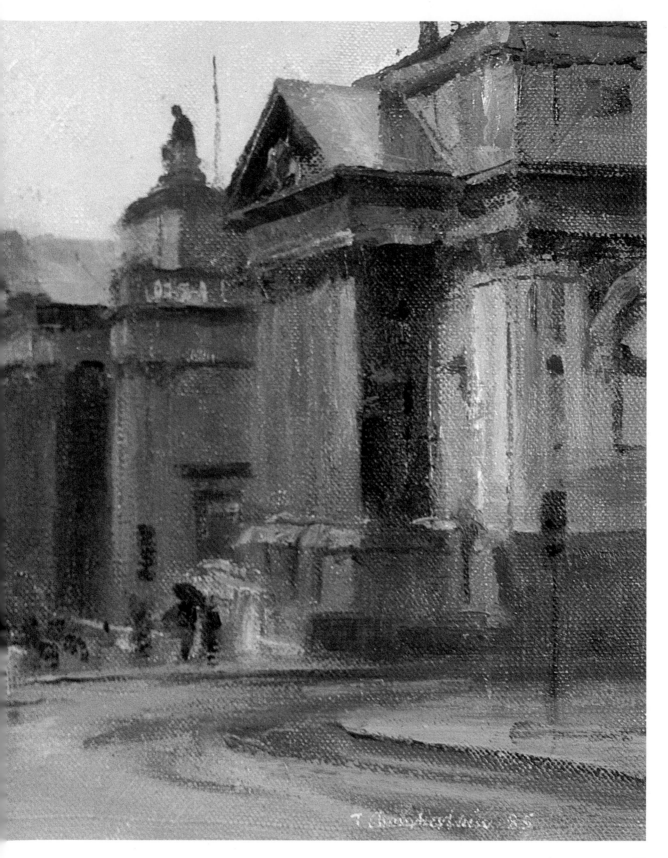

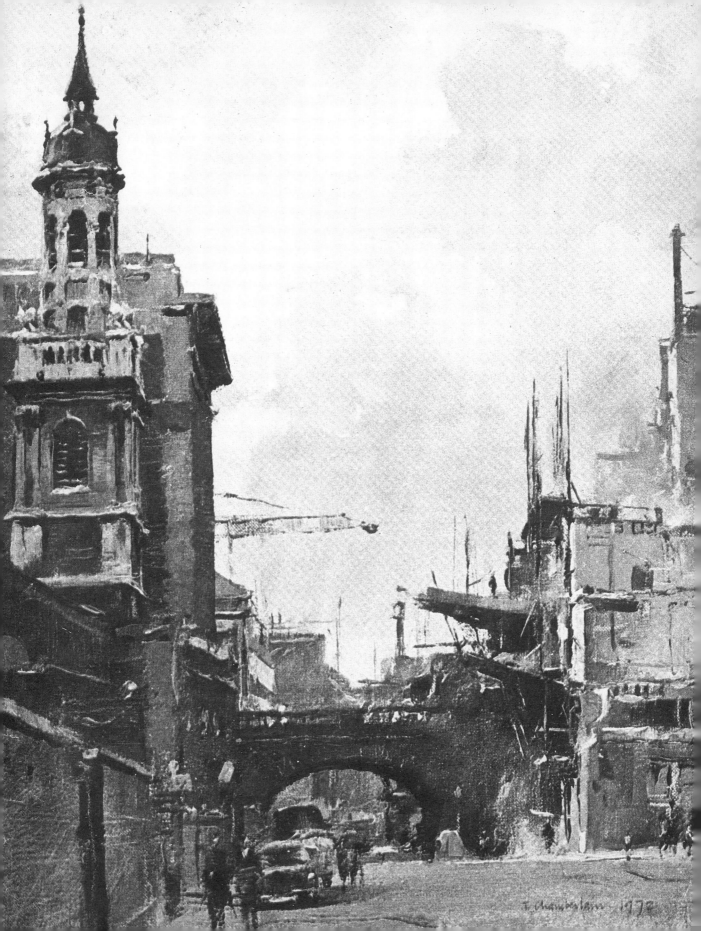

*Previous Spread*: 'It Rained all Day', 10 in × 14 in. First and foremost it was the atmosphere and the interest of the grand buildings which reflected Liverpool's prosperous past.

*Opposite*: 'The Demolition of the Steam Packet', 20 in × 16 in. There was so much going on it became a challenge. With a church, old London Bridge, the demolition and the tower crane and, of course, the light on the dust.

*Below*: 'Morning, Ashmolian Museum', 10 in × 14 in. There are strong linking shadow shapes here. He painted the elaborate Oxford City architecture very simply.

One hazard you'll never be able to avoid while painting townscapes is the curious onlooker, and you've got to decide beforehand how you're going to deal with them – whether to ignore them sternly, or to make appropriate grunts at the right time whilst keeping your whole concentration on the painting. I don't know why it is, but everyone seems to trust artists and think of them as safe companions, whereas they'd never think of chatting to you without an easel in front of you. One trick I've found, is to get your back against a wall or into a corner before you start. It infuriates the passers-by who can't see what you're doing, but it gives you some sort of peace of mind, and of course, it's in townscapes that the Pochade box is so useful, because one really can be so unobtrusive with it.

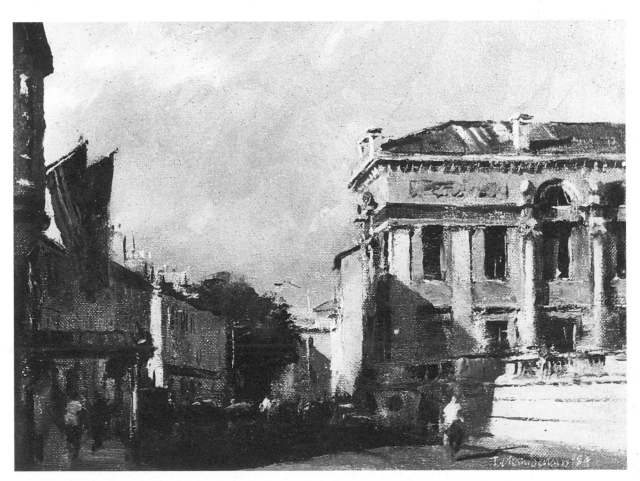

# Interiors

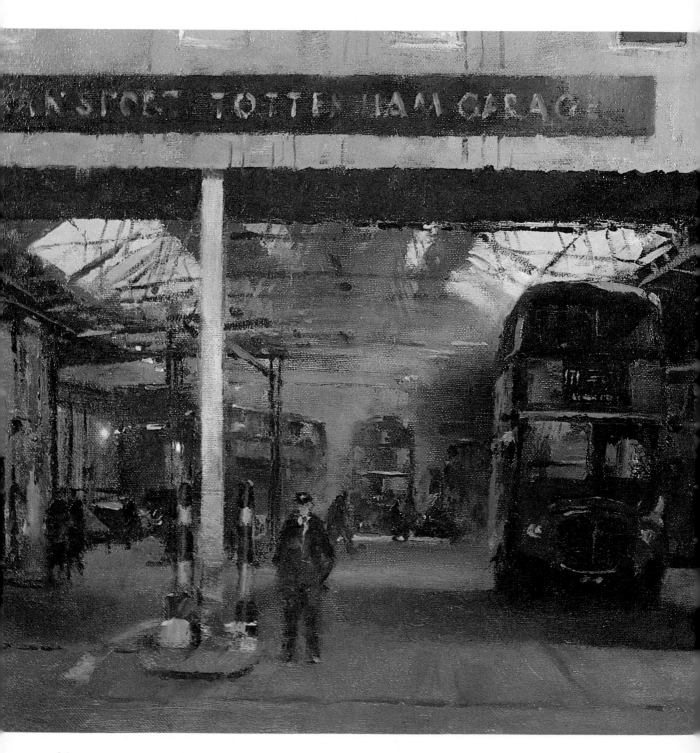

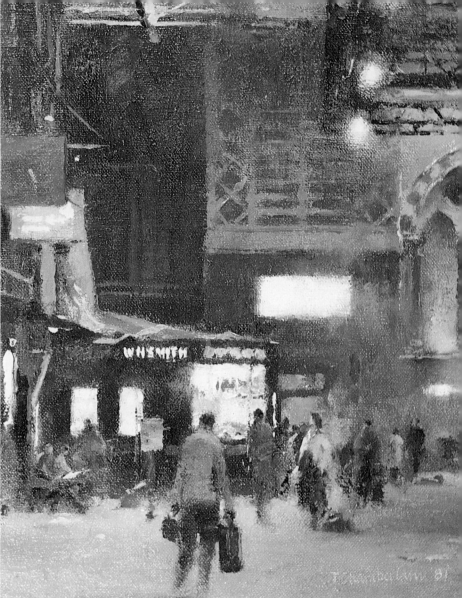

There's been a long and honourable tradition of interior painting over the centuries, with many great artists devoting much of their output to them. My own favourites in this area are Degas and Toulouse-Lautrec.

When I asked Trevor what really drew him to such things as railway stations, market halls and bus garages, it came back (as it inevitably does with him) to the interesting visual effects produced by the mixtures of natural and artificial lighting, and even

*Left*: 'Fred and the 171', 16 in × 20 in. Trevor was attracted by the atmosphere of the diesel smoke and the colours of the buses, together with the general bustling atmosphere.

*Above*: 'W.H. Smith, St Pancras Station', 14 in × 10 in. The interesting effects from the neon lights, the skylight and the warm light from the bookstall. Also the simplified architecture.

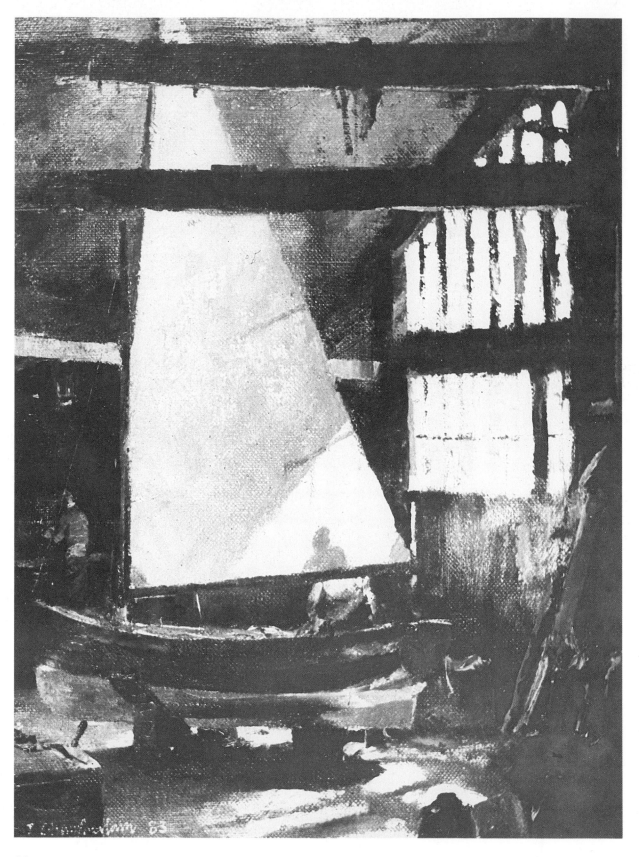

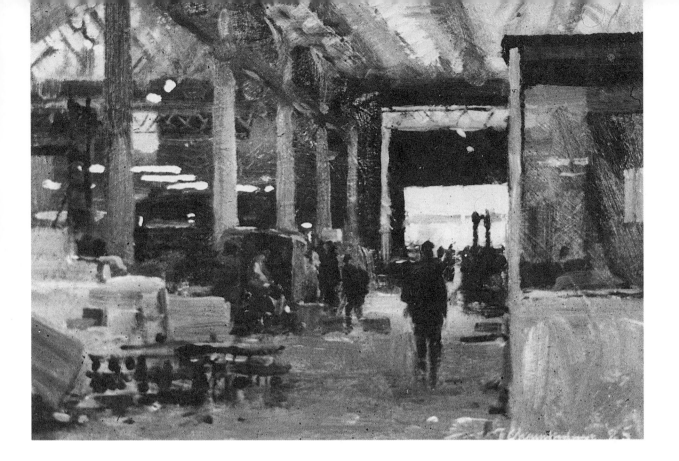

*Above*: 'Spitalfields Market', 6 in × 8 in. He painted this with the pochade box, tucked away in a corner of the fruit and vegetable market. It was a very complex subject with Victorian roof structure and boxes and general bustle. He painted it in an hour and a half.

*Opposite*: 'The New Dinghy', 14 in × 10 in. He was passing a boat builder and saw the finishing touches being done with all the sails up. It was an arresting shape and dramatic image.

the influence of diesel smoke, which he's used in the bus garage on page 46 and the railway station on pages 34/35.

He's also attracted by the interesting tracery of the mainly Victorian roofs and skylights and the opportunity for portraying strong darks and rich colours.

He often notes a situation days or weeks beforehand for its particular potential then on the day he decides to paint he usually gets permission first, even if its only from a porter, and settles down out of everyone's way, if possible with reasonable light to work under. The two aren't always compatible, of course. However, he would soon have heard some rich language if he'd got in the way of the porters at Spitalfields Market.

There is always plenty of opportunity in these situations for portraying figures doing things, and also for them sitting long periods, unconsciously acting as models. One thing you haven't got to worry about is the weather, so you can carry on even if its snowing or raining outside.

Churches, cathedrals and abbeys have great potential too, look at page 24. The interior of old barns give more opportunities for paintings; study the work of Sir William Russell Flint in this direction. Again, the pochade box is invaluable for letting you paint unobtrusively.

# Figures and Cars in Landscape

Figures can make or mar any landscape. So many people know this and are afraid to take the risk, so they paint an empty street scene, hoping everyone would assume it was done at 5.0 a.m. before the population was up.

Obviously many pictures are better without them and figures will not contribute anything to the quality of the painting. In others the figure is the whole *raison d'être* – look at the paintings on pages 7 and 114 for example.

In the market and city street scenes, too, they are an essential element. Obviously you should vary the size of the figures to give depth, but remember that in a flat street, whatever the distance apart, their heads should be on the same level. A good example of this is on page 28. I also love to see people working on boats, they seem to give the scene more credibility.

The almost universal fault I've found with amateur artists is making the heads too big. Figures wander round an otherwise perfectly good picture looking like little garden gnomes.

The next fault is over-detailing. Everyone seems to tighten up suddenly when it comes to putting in the figures and paint them in an entirely different technique. They might even have been done by someone else completely. It's all due to lack of confidence. If you look at the illustrations here you'll see how simply the figures are indicated, some of them are merely silhouettes, but the proportions are right and the heads are small.

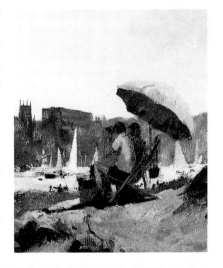

To generalise, make your figures tall and elegant, not small and dumpy.

Another thing is that you don't have to put in the feet. I discovered this from studying Edward Seago's paintings, but I see Trevor treats feet in the same way.

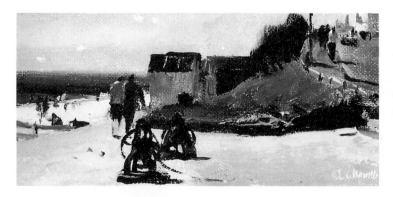

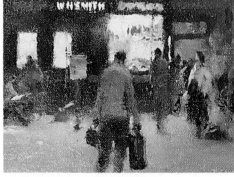

50

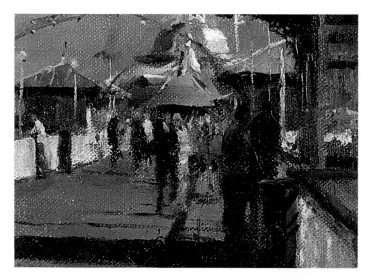

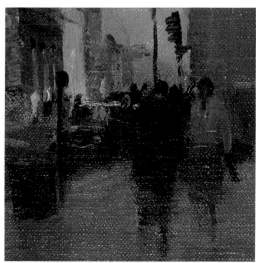

Cut-outs from the various
pictures show the elegant
proportions of the figures and
the lack of feet which help to
convey the feeling of movement.

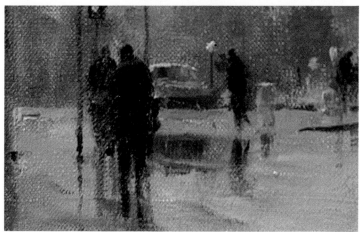

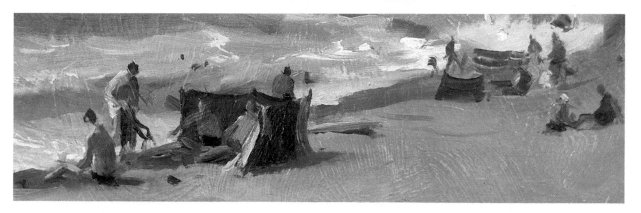

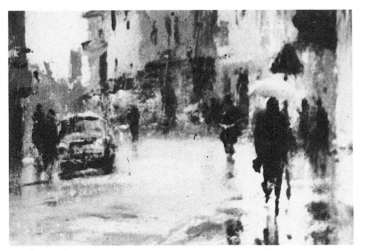

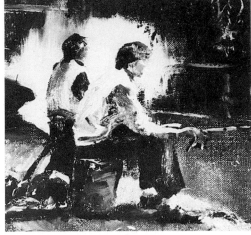

Except in the case of parked cars and specific figures they are just vague, moving shapes, but indicated in the right proportions.

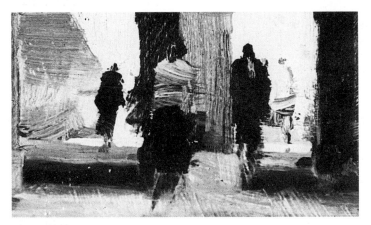

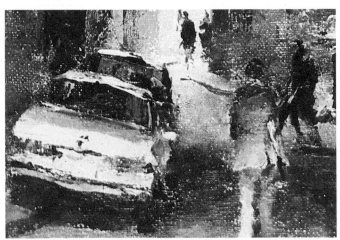

If you look at the illustrations in the rest of the book you will see how important figures are in many of the other landscapes. They can be used in different ways to give movement and scale to a scene. Take the interior of the cathedral on page 24. The whole vastness of the place is shown by the simple figures in front of the altar. The picture also shows the importance of counterchange. If you want them to show up, put a dark figure against a light background and a light figure against a dark one. Figures, however, must be put in as an integral part of the scene not just as an afterthought.

You must also make sure that they're in scale with each other and with the buildings near them, so check that the man next to the door can get through it without going down on his knees.

Another tip that I've found useful is to draw your figure first on a piece of tracing paper and push it around the landscape until it looks completely in scale with its surroundings – but watch out for the wet paint.

Turning to cars, a lot of the same rules apply, as long as the basic silhouette is right it's surprising how little detail you can get away with. Here again the problem is usually over-detailing. You don't have to be an engineer to place a car in a landscape. As long as you give them half a chance, your viewers are quite willing to use their imagination.

How can you get your figures to match your landscape in freshness and lightness? There's only one way I'm afraid – that is practice. So, put a sketch book in your pocket, with a soft pencil, and take it around with you, making rapid sketches of people and cars in the street. Keep them small and simple.

The most important thing is the action and the gesture of the figures and the basic silhouette of the cars.

Finally to consider animals in landscape – cows, sheep, hens, etc., again look through the book and see how Trevor has put little if any detail in any of them. If they're any distance away one can dispense with the legs for a start. Treat them more as light or dark silhouettes and counterchange them against their backgrounds.

Remember, too, when you have a crowd of people or even sheep all together, like trees in a wood they lose their individual forms and should be treated as a simple mass.

'Willows in Winter',
16 in × 20 in. It was a perfect day
with warm sunlight on snow,
mauve shadow and distant trees
– an absolute natural.

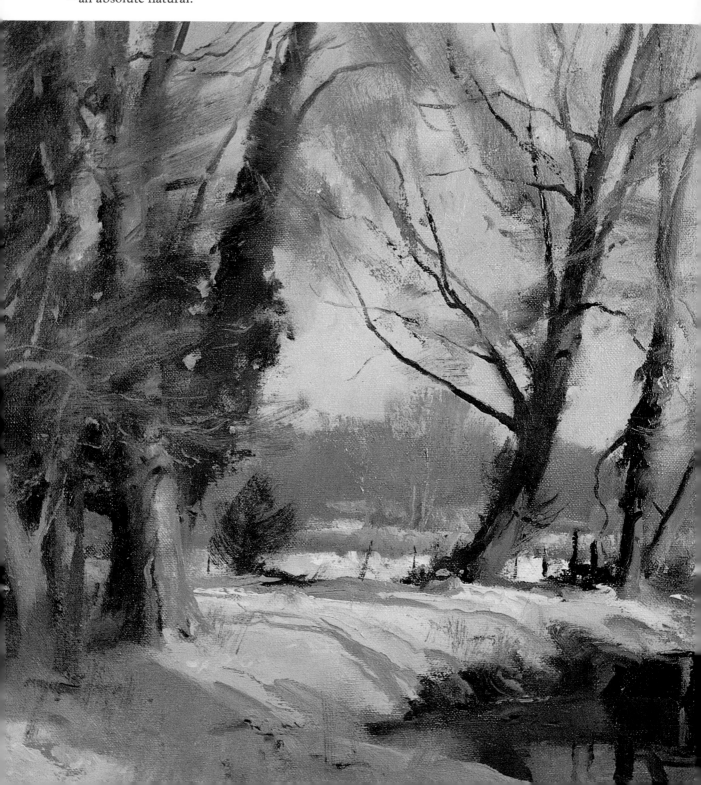

# Winter

Winter is the season of warm and cool greys and subtle browns and a winter landscape offers the painter a feeling of quiet dignity.

Snow scenes too, give artists the opportunity of designing their picture space with light areas contrasting against the dark tree forms. In winter too one sees the real anatomy of the trees making beautiful subjects to paint. You can see how the parts gradually diminish from the trunk through the branches to the twigs at the very end. When you're painting the bare trees in winter don't forget twig masses. So many times I've seen students paint the trunk and branches and leave out the grey tones formed by all the thousands of overlapping twigs.

The success of a snowscene depends on the composition and balance. Compose your picture in terms of pattern. Don't let the light and dark be equally important, let one or other predominate. Never make your snow field too light; it is never completely white as it constantly reflects the light poured on it from various weather conditions. A warm glow of sunlight might give a tinge of yellow or gold at sunrise, and even pink at sunset. The blueness of the skies is caught in the shadows, where the direct rays of the sun don't reach. The contrast of cool and warm colour seems to intensify them both.

Don't always paint sunshine on snow, try it on a cloudy day. I find a really threatening sky on a snow scene is very effective. Of course, this too modifies the colour of the snow beneath it. Most of the snow surfaces are smooth, but often broken up when grass and stony earth show through it. Shadows are very important in snow scenes, as they describe clearly the contours of the surface they fall on. You may think that it goes without saying that you should first establish your source of light and stick to it, making sure that all the shadows lie in the same direction, but I've seen some very confused paintings where the student has forgotten this half way through.

There are lots of grey colours in nature and in Trevor's paintings, often produced in subdued conditions, there is an infinite variety of warm and cool greys. Forget about mixing black and white together, which is what so many students try to do, because there are so many better solutions.

The best way to grey down a colour, which is lowering its intensity, is by adding its complimentary colour. For example, you can grey a red by mixing some green with it, or orange by

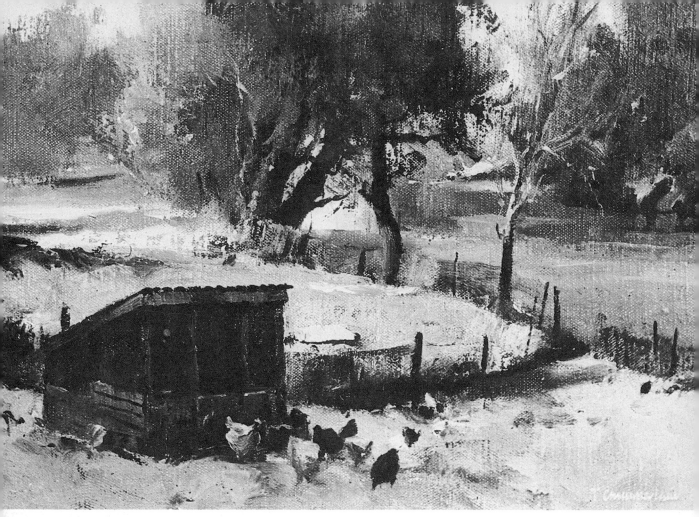

adding blue, and yellow by adding violet. These are all mixtures of complimentary colours. You can also mix white with your colours to produce many greys. Whether they're warm or cool, greys will depend on how you vary the proportions of the colour you use. For example, if you want a warm grey, you should allow red to dominate the mixture, but if you want a cool grey, let blue be the dominant colour. Learn to train your eyes to observe the subtleties of greys in nature, as well as the more obvious colour effects. You don't have to go all out for contrasts of intense colour to paint a brilliant sunlit landscape.

Winter is also the season of mist, which is composed of fine particles of water suspended in the atmosphere, virtually a cloud on the ground. These particles are like a series of veils between you and what you are looking at. The greater the distance away the more veils and the less you see. Don't make the mistake of painting everything woolly and soft. Nearly all modelling is eliminated in mist and you will mostly be painting silhouettes, so the objects in your pictures should have interesting contours retaining their crisp, sharply defined outlines. Use a strong interest in the foreground and always paint it boldly and richly so that your picture will have a firm anchor to it.

'Free Range Chickens', 10 in × 14 in. One wouldn't really think of painting hens and a chicken coop but they were rather nice shapes and the counterchanging happens throughout the picture.

'Snow, Little Hartham',
20 in × 24 in. Quite a large
canvas to paint outside in these
weather conditions. It took two
sessions. Roughed out on the
first day and finished off the
second day. Luckily the horses
kept returning to the bower.

Now, a word about warm and cool colours: orange, red, yellow, green and brown are what we call warm colours; cool colours are blue, violet and blue-green. In painting, warm colours appear to advance and cool colours seem to recede, so to obtain the illusion of depth, you should use the cool colours for the distant parts of the picture and place your warm ones in the foreground.

As to darks and shadows in your paintings, again forget about black, which is completely lifeless as compared to the darks made from mixtures of other colours. Shadows aren't black anyway, they have colour and in most of them there's reflected light

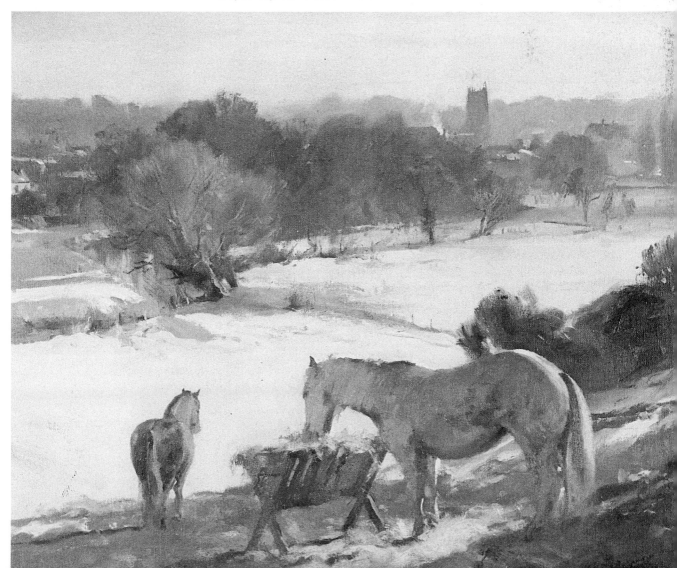

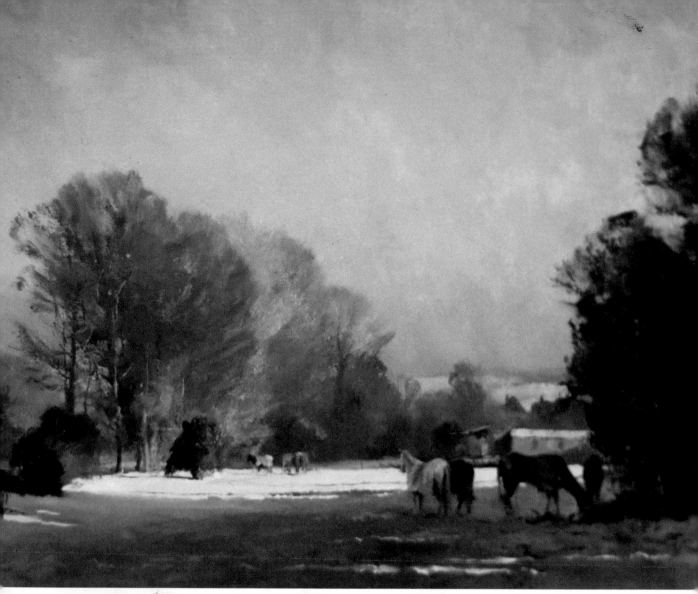

*Above*: 'Winter morning, Horns Hill, Hertford', 16 in × 20 in. He was attracted by the warmth permeating the scene, although it was a cold subject. There's a lot of reflected light in the shadows.

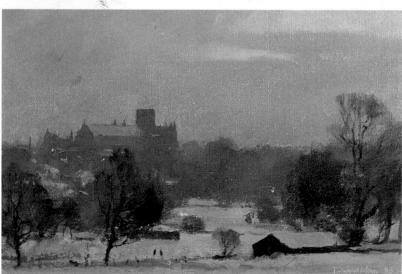

*Left*: 'Snow flurries, St Albans. A distant view of the cathedral in a diffused light, with very subtle warm and cool greys. Note how dark the snow is, in comparison with the white paper around it.

from nearby objects or from the sky above. The colour of a cast shadow is also affected by the colour of the surface it's cast on. The shadow cast on a sandy beach or a road isn't the same colour at all as the one cast on grass. For example, if you think of a Cotswold stone wall, its warm colour would be reflected in the shadow close to the wall, while the shadow area furthest from the wall would receive cool light from the sky.

A warning about white paint. The large tubes which most of us have in our boxes might easily tempt us to overdo the dose, and using too much white is as bad as using black. They both tend to deaden the other colours you mix with them.

You can't create the illusion of light by adding more and more white, in fact paintings which best convey this feeling of light are really rich in colour. Think of Van Gogh's work.

It's especially easy to be tempted into using too much white when you're painting out in the open air, particularly tackling 'watery' subjects. The sun shines on the river, there are white sails about, but look more closely and you'll see that the colour isn't as light as you first thought. It's quite rich after all and you

'Winter, Castle Mead, Hertford', 7 in × 10 in. This was painted in late morning. The eye is led round by the river towards the spire which is the main point of interest and is deliberately positioned off centre.

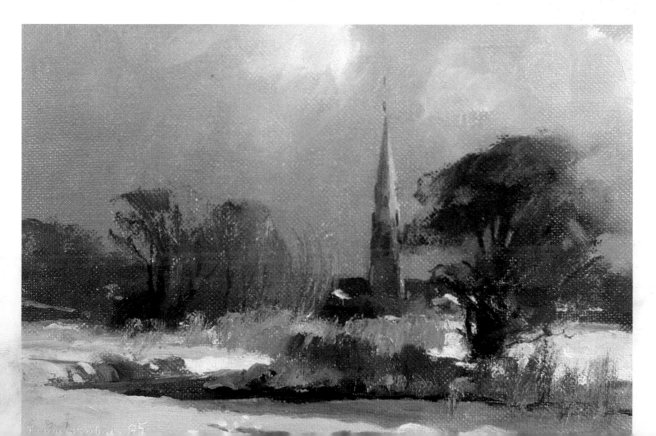

won't be able to convey it by piling white paint onto your canvas. It'll just look chalky.

Look at the coloured sunlit paintings in the book, especially the snow scenes, and you'll see how rich they are compared with the white of the paper that surrounds them.

Now to skies and clouds. These set the mood for the rest of the painting and Trevor invariably paints them in first, once the main blocking-in is completed. If you're depicting a foggy day or a quiet morning or evening scene, a flat, simple sky would suit the mood, whereas a bright windy day might call for a bold, really textured, sky with active clouds.

One sees so many weak skies because the main fault with students is always timidity, what they really need is more courage!

However, a few basic facts about skies might make them look more convincing. Clear blue skies don't present any problems as long as you remember that they're not flat blue like a sheet, but are darker above and become lighter and creamier as they approach the horizon. Coming to the clouds themselves, first don't

'Rain and floods', 7 in × 10 in. Here the dramatic effect of flooded fields with the water swirling round the trees which are actually the same as in the Winter Demonstration, but with a completely different atmosphere.

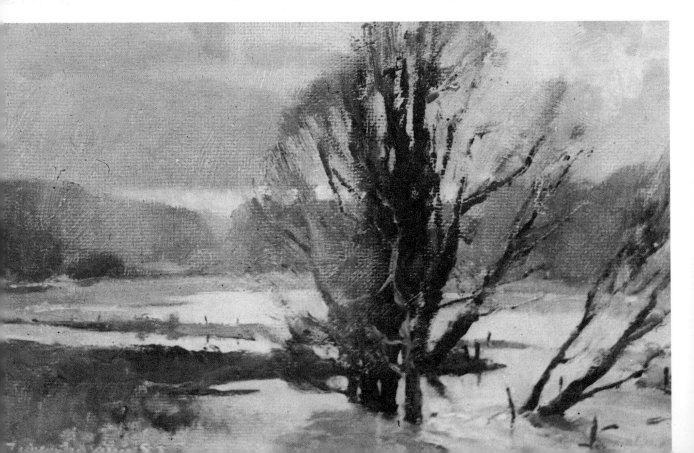

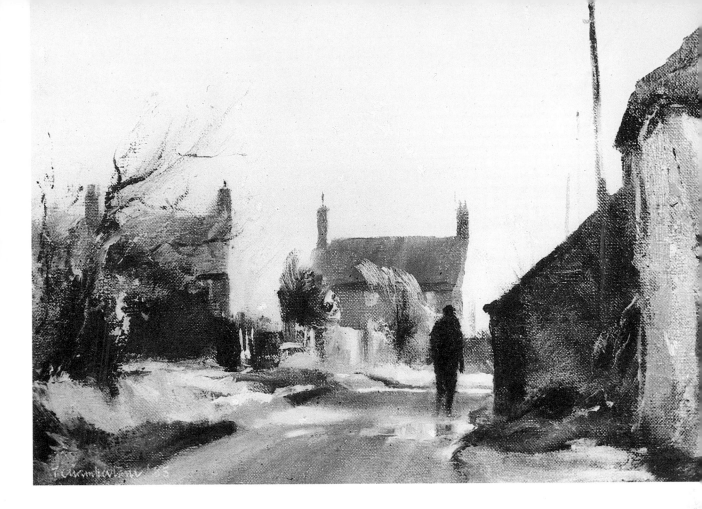

'January afternoon, Norfolk',
12 in × 16 in. A very warm
afternoon light throwing up the
barn with a solitary figure
heading out of the cold winter
wind.

forget that clouds too have perspective. The biggest shapes are always in the foreground or overhead and as they go back towards the horizon the shapes get rapidly smaller. Make the cloud base overhead fill half the foreground and have the background clouds very much smaller. Strong contrast in size will also help to pull the viewer into the picture.

Get the feeling of an enormous expanse of sky and then try to put this feeling down on canvas.

Let's look briefly at the different sorts of clouds. Cirrus is a thin wispy, high cloud. Cumulus is a white woolly cloud, very impressive but difficult to paint. It has a light creamy top where the sun catches it and a shadow underneath. Storm clouds or 'stratus' are flatter and appear to move more slowly. They are best painted swiftly and left alone. Of course, in reality, things are more complex than this and one gets the various types overlapping.

It's very easy to overwork your skies, but if you do, wipe them out with a clean, soft rag moistened with turps and start again.

To a certain extent, painting clouds has to be memory work and you can't change your painting as the cloud formations change. It's a good idea to make a very rapid sketch of the overall

pattern first and then paint from that, just glancing now and again at the sky for colour.

Finally, a simple rule to remember. If you have a complicated landscape, give it a simple sky, but if you want an elaborate sky, set it against a relatively low, simple landscape.

Representational art is really an illusion created by the painter and this illusion is obtained mainly by the correct relationship of the tonal values, not by minute detail.

So you can see how vital it is for you to get this tone right.

Forget about colour for the moment, concentrate on the general shape of the object, but even more important is its tonal value (its lightness or darkness compared with the other objects around it). Think how it would look on a black and white TV screen.

I find it very helpful to screw my eyes up when I'm comparing relative values in the scene, because this seems to filter out the colour and makes lightness or darkness more important. Keep asking yourself, 'Is that lighter or darker than what's beside it?' The same process when looking at your painting afterwards will

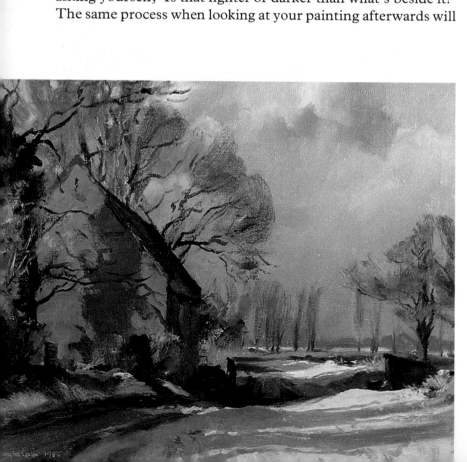

*Left*: 'Norfolk thaw', 14 in × 20 in. There were rich warm shadows on the gable end and across the foreground, together with a sense of distance beyond the poplars.

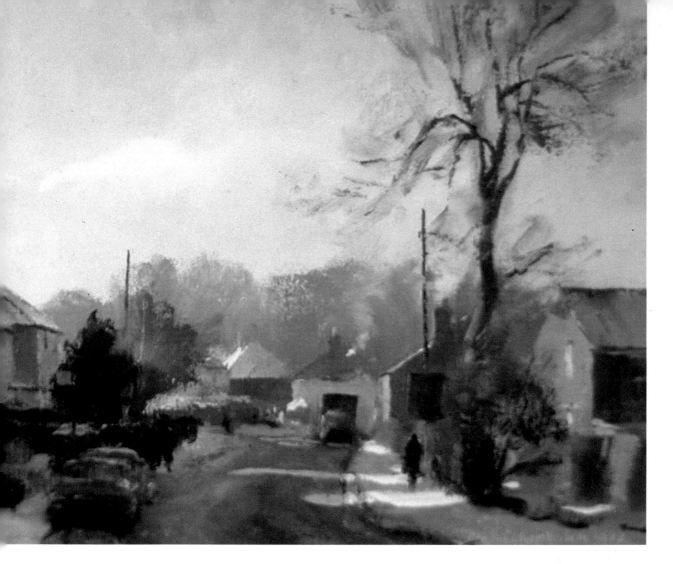

*Above*: 'Late Afternoon Light', 30 in × 48 in. This is a studio painting made from a smaller one produced on the spot. There's a dramatic light on the poplars and a lot of colour in the shadows which throw up the warmth of the sunlit area.

tell you where you've got it wrong because adjacent objects (even if green and red) will then disappear into each other.

Counterchange in a painting is very important, that is the placing of light shapes against dark and the dark against light, basically like a chess board. This principle should always be locked into your mind while you're painting. All the Old Masters used it, of course, but few amateur painters seem to give it a thought. Look at the pictures in this book, and you can see where Trevor constantly uses this counterchange. For example, look on page 56 how the chickens have been counterchanged, white ones against the dark shed and the black chickens against the light ground.

Nature itself, very often, provides these tonal contrasts, but if not, you must rearrange and emphasise them yourself.

# Winter Demonstration

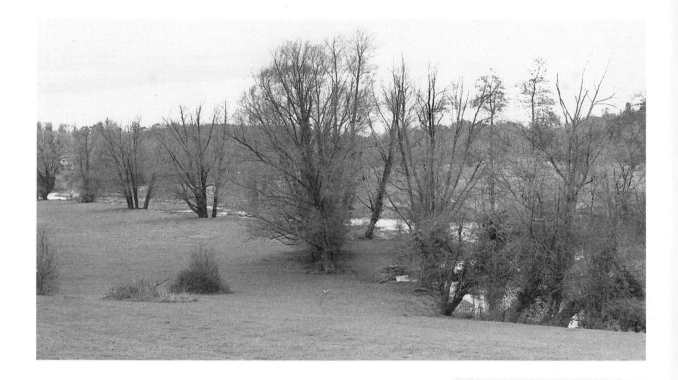

It was cold, really cold that day, with a high wind and racing rain clouds. The location was near Trevor's home, and he, the photographer, and I huddled under an open-sided cowshed overlooking the river. While two of us were shivering in the wind, Trevor, with his jumpers, padded coat, hat, boots, and shooting gloves seemed, not surprisingly, to be quite impervious to the conditions around him.

Trevor started by sketching in the main area with charcoal. It all looked very casual and sketchy, but it contained the most important thinking involved in the making of the painting – the overall design and composition. Often in their enthusiasm to start painting, many students ignore the importance of the big design. Remember, this is the time you're making the decisions you will be stuck with throughout the entire painting. However, look how simple and direct his lines are.

Then came the underpainting with a large brush. He broadly, but thinly, blocked in the main areas, approximately the correct tone and colour tint, using pigment well thinned down with turpentine and gel. Once the canvas was completely covered and almost immediately dry, he painted in the sky with a palette

*Above*: The first rough in charcoal.

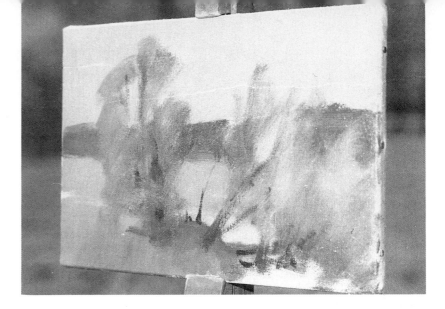

*Left*: Photograph of the scene. Trevor selected a small section of the panorama.

*Right*: The first laying-in with thinned paint to establish the tonal values.

knife, softening off with his fingers and a brush. Trevor always puts this in first as he feels that the sky sets the mood and influences everything else.

From then on he worked from the back to the front, painting in the background trees as a simple mass and putting in the foreground trees on top with a knife, and the bare branches being added with a sable rigger.

One of the main points of interest in the picture is the river itself, and this is emphasised by the counterchanging of the dark trunks of the trees against the light of the river. Do remember this if you really want to draw attention to a part of your painting – put your darkest dark next to your lightest light. It always works and the Old Masters knew it too.

He was working intently, occasionally screwing up his eyes, as well as stepping back some six or eight feet to judge the progress. In about one-and-a-half hours the painting was apparently completed, and we parted. The photographer and I drove homewards while Trevor took the picture back to his studio,

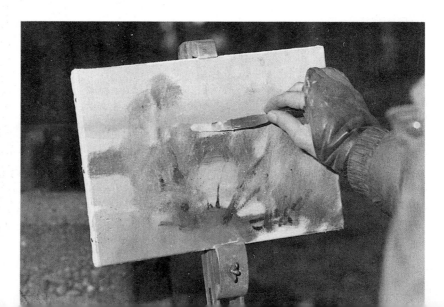

*Right*: The sky is being put in, mainly with the knife, softened with the fingers and brushes.

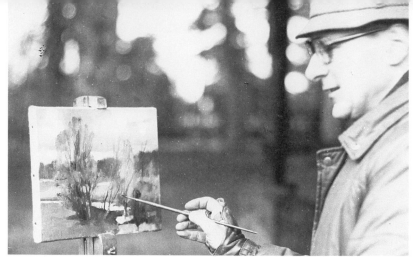

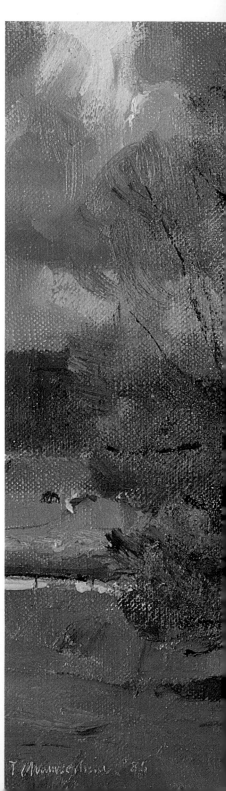

and placed it on an easel, studying it very critically and making modifications to many of the tones and details. It is at this stage that he stands with his back to the work making use of the hand mirror. It gives a different aspect. Seeing a painting in reverse image quickly reveals mistakes in drawing and value. The most common drawing errors occur in horizontal and vertical alignment. The fact that artists are right or left-handed leads to an unconscious slanting of perpendicular lines, and such mistakes are best detected by viewing them in reverse mirror image where they show up straightaway.

Whilst producing most of the painting on the spot in the open air gives it great feeling of vitality, much of the subtlety of the work is attained during the hour spent in the warmth of the studio afterwards.

In fact, it's rather like writing a book. You put your main thoughts and meanings down on paper, but when you see the typed draft you go through it carefully, altering a word or sentence here and there, to make it flow more easily, or put the message over more clearly. It's a 'honing-down' process.

*Below left*: A photograph of the artist at work.

*Below*: 'Cold landscape', 10 in × 14 in. The finished painting.

*Left*: The bare branches being indicated with a sable rigger.

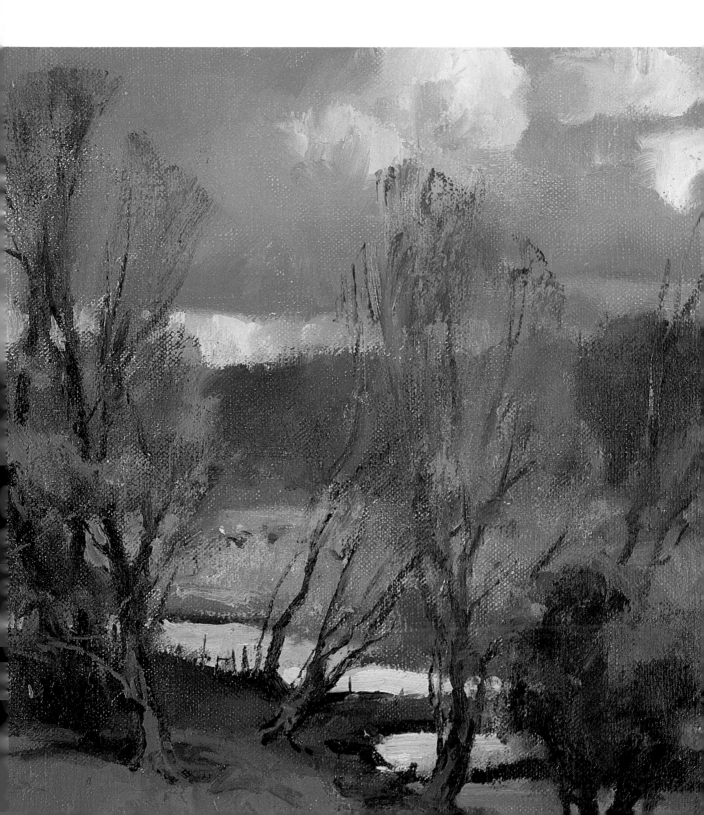

'John MacKay at Greenwich'
10 in × 14 in. This is another
view of the ship at the bottom of
page 19, painted on the same
day. The position of the small
rowing boat was important as a
linking feature.

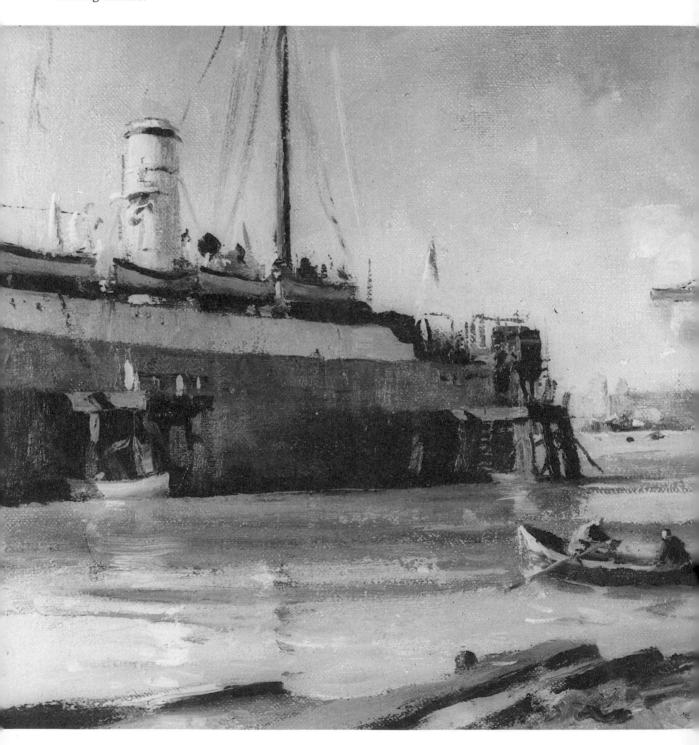

# Rivers

Without doubt, rivers are my own favourite subject for painting, and, judging by the proportion of river pictures in this collection, Trevor's too. I confess, I can never go over a river bridge in a car, without wanting to stop and get my easel out.

Apart from being very good sellers, something the dedicated artist should perhaps disregard, river pictures give opportunities for so many variations on the theme and so many different subjects, such as trees, buildings, boats, bridges, people and reflections to name but a few.

However, let's start with the main mistake of students which is a tendency to make rivers appear to flow uphill. I suppose a third of all the river pictures I see on my courses reveal this fault. They make the height from the furthest point to the front too deep and the line of the banks is at too steep an angle. Also, as the river goes round the bend, they tend to make it appear to tip over on its side, showing too much of it. These flaws are caused through lack of observation, and everyone can see them once they are pointed out. However, I've seen so many otherwise good river scenes ruined in this way.

Now to the water itself and the reflections. Water by itself has, of course, no colour, but it gets its apparent colour by reflecting things about it. On a clear, bright day, the river would be predominately blue, but on an overcast day it would be grey. This sounds obvious, but, in paintings, I've seen so many stormy skies over blue rivers. In a shallow stream, the water will get some of its colour from the bottom gravel and from the sky.

Basically, think of a calm river as a soft mirror. Reflections of boats, bridges and other objects, all lend their colour to the water, so reflections are mostly the colour of what's being reflected. If the surface is ruffled by a breeze, the reflections will have more variety of colour because the tops of the ripples will sometimes reflect the sky, while the water between them reflects things on the bank.

The reflection of a sunlit white boat on calm water is almost white, probably slightly darkened by the particles in the water, especially if it's muddy. Conversely, a dark boat's reflection will probably be lighter than the boat itself as the sky adds lighter colours to it.

Use mainly vertical strokes when you're painting reflections, then cut across them with one or two horizontal strokes to establish the plane of the water.

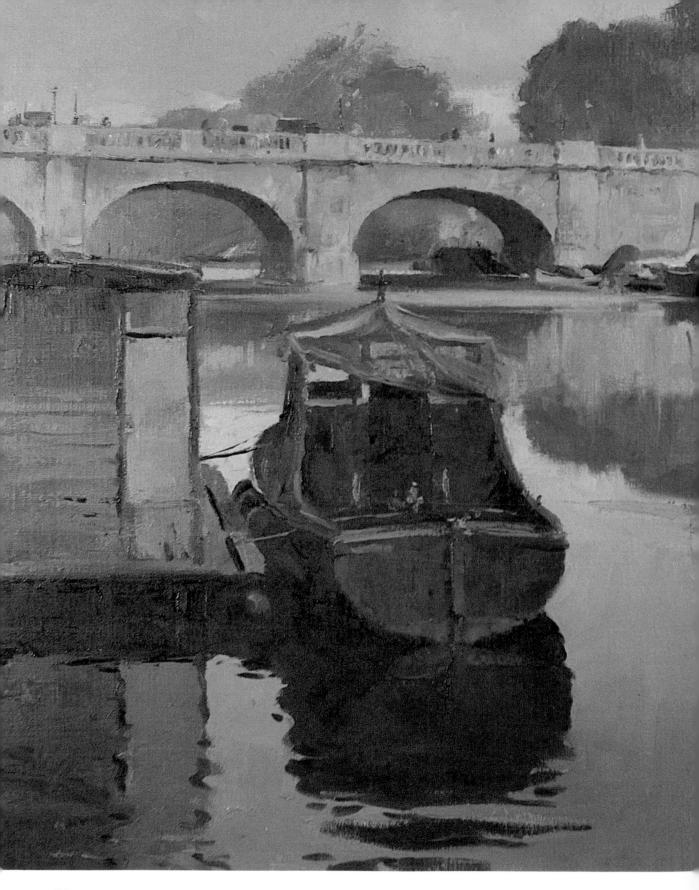

'Dull still evening, Kingston', 24 in × 30 in. This was a studio painting made from a smaller one on the spot. The whole scene was in the shade with the lack of any direct sunlight, Trevor really had to look hard to discover the forms of the various objects.

On large stretches of water, such as lakes, the surface is made light where it's farther away, and dark in the foreground. This is because the horizon reflects the low, lighter part of the sky, but close to the shore the water picks up the darker colour from the sky above. Also, because we're looking down at it, the foreground water transmits some of the colour from the bottom.

Some parts of the lake surface are smooth while others are ruffled by the wind. Smooth water reflects the sky like a mirror and the rough water picks up and relays the light from many directions, either darker or lighter than the sky depending on the prevailing conditions.

Water in a stream tumbles and flows in parts. Watch its movements very carefully for quite a long time and then try to paint a generalisation of this movement. Brush strokes should follow the action of the water. Don't put down every ripple as rushing water looks much better when it's understated, and the absence of detail makes it look more rapidly moving.

River scenes often involve boats, so let's tackle them now. Many people have a deep fear of drawing boats. Their normal intelligence seems to desert them and they produce some awful monstrosities. 'I can't draw boats and I don't know anything about them,' is a common cry from students.

If you go about it in a logical way, boats are no more difficult to paint than anything else. First of all, learn the basic form of the hull and think of it as a 'shape' and, very important, keep looking at your drawing and back at the boat itself over and over again. I've often watched students drawing boats. It's one glance and eyes down. They just haven't got the habit of constant critical comparison which is the only way to draw accurately. Draw in lightly the centre of the boat from bow to stern and this will stop you drawing in bits of the boats such as the mast off balance.

Try and sense how the shape of the boat is related to its particular job and feel its character – its lightness or heaviness, its strength or fragility. Don't make them too big within the picture, or instead of a composition you'll end up with the portrait of a boat. When you draw sailing boats, either pull the mast right out of the picture or keep it clearly inside. Don't just have it touching the top of the canvas looking as if it was dangling from it. Do, by the way, make your masts tall, I've seen so many students make them stumpy.

'Below Kew Bridge', 10 in × 14 in. A very atmospheric painting done in summer, but looking like November with variations of grey. The gas tower in the distance would have appeared right in the middle so it was judiciously moved to the left.

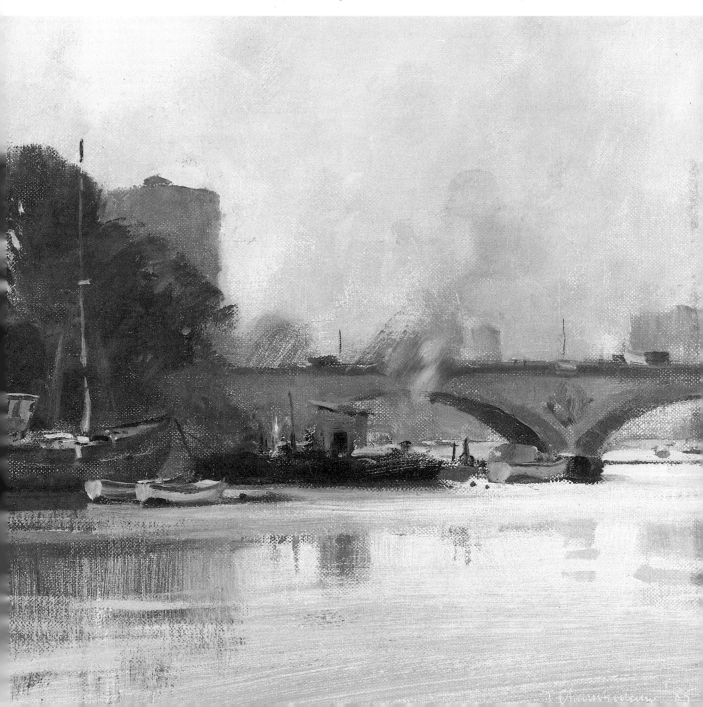

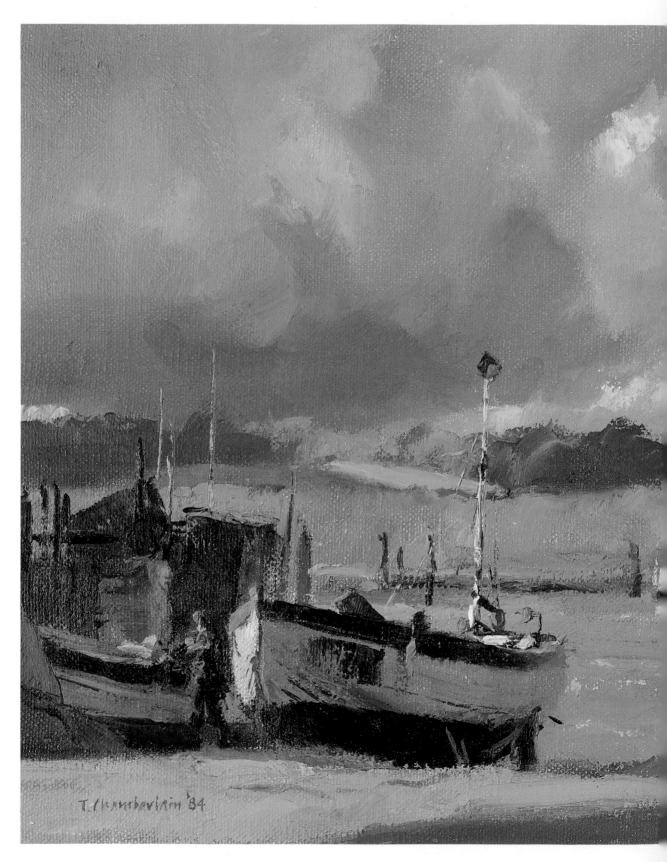

T. Chamberlain '84

'Turbulent sky over Warbleswick', 10 in × 14 in. This was a very lively windy day with quickly changing contrasts of bright sunshine and overcast. Trevor tried to get the transience of the mood. Note the counterchange of the dark church against the lightest part of the sky.

The word *composition* is rather a daunting one, but all it really means is the placing of the main masses within the picture, deciding in your mind where you're going to put the horizon, buildings, trees and other elements of your painting. Painting itself is a series of decisions, expressing your own personal good taste, which will produce a painting that has dignity, elegance and a sense of rightness.

Let's talk about composing your painting – without going into too much theory. There are only a few basic rules to follow, which are very much common sense. The centre of interest is the most important point in the picture and is, of course, the subject. The placing is crucial and it's your job as an artist

'Tugboat at Maldon', 16 in × 20 in. This was a really lucky one. The tide was out, the tug was in the right position to be painted and the sun was shining. A nice natural design.

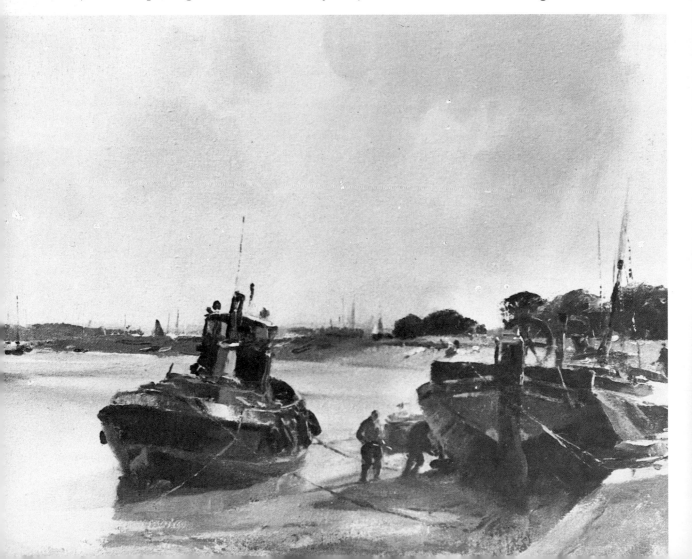

'Old Wharf, Isleworth',
16 in × 20 in. The most exciting
thing about this was the dark
reflections in the river
accentuated by the light mud.
The lone figure (with dog?)
helps to give it life.

gradually to take the viewer's eye to it. There are several ways of emphasising this centre of interest, which should never be placed exactly in the middle of a picture, but set to one side or the other. One way is to make it the point of most dramatic counterchange in the picture; in other words, putting your darkest dark next to your lightest light, or it could be the spot where the colour is most intense. A single distant figure, or a tree, can be very dramatic, however small, if it is isolated and if, for example, the curve of a hedge leads the eye directly to it.

You as a painter have the power, once you have learned how to use it, of controlling your viewer's eye. The Old Masters, of course, knew it perfectly. Take the Adoration scenes for example. The heads of the crowd would be so arranged as to make a curve leading to the Baby Jesus and this would also be the point of the most intense light in the picture.

You can learn a lot by looking at the illustrations in this book, specifically searching for the ways Trevor has used to emphasise the centre of interest in each of his paintings.

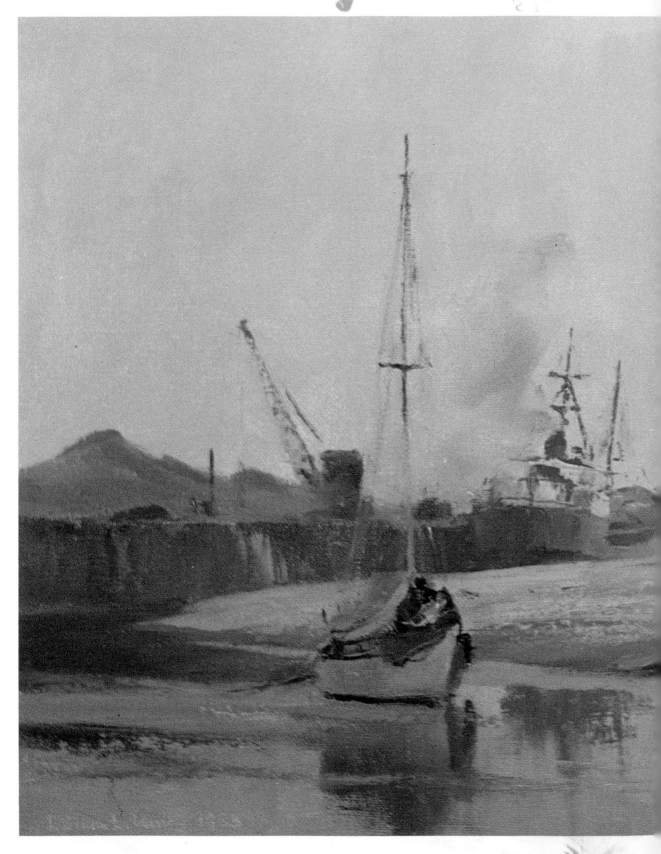

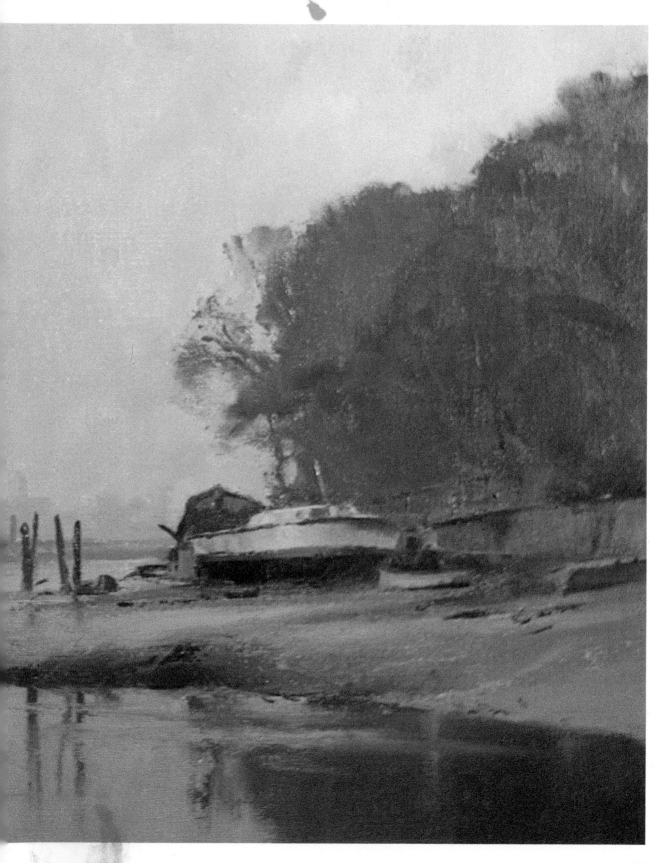

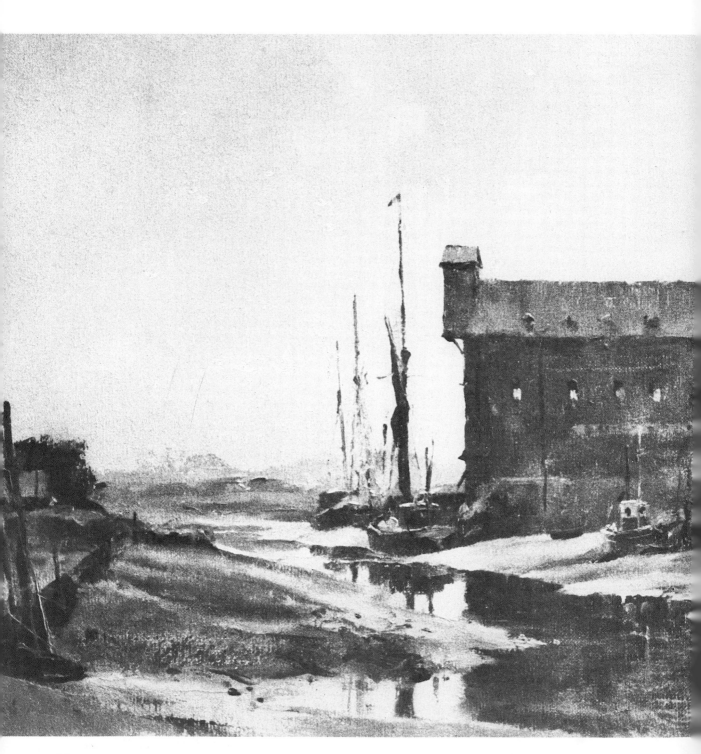

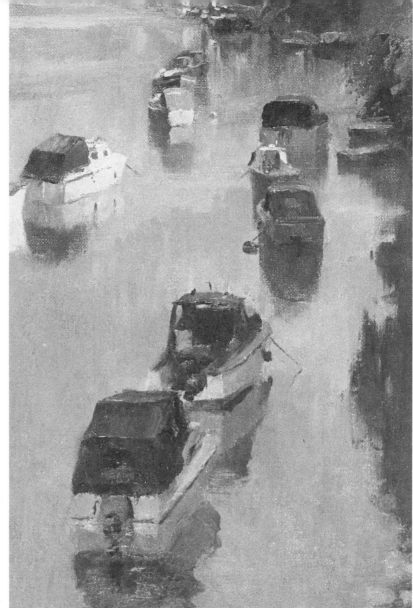

T. Chamberlain 1978

*Above*: 'The Line,
Twickenham', 14 in × 10 in. This
was an unusual viewpoint and
Trevor liked the way the boats
were just positioned up the river
into the distance.

*Left*: 'Low tide, Faversham
Creek', 16 in × 20 in. There's the
strong straight shapes of boats
reflected down into the water; he
tried to get the effect of a 'skin'
on the surface of the water
which you seem to get when
there's dead stillness in the air.

*Previous spread*: 'Bleak day,
Eling Creek', 14 in × 20 in. This
was a dull, grey, drizzly day,
painted at the head of
Southampton Water, difficult to
keep the rain off the palette.
There's a close harmony of tone
and colour.

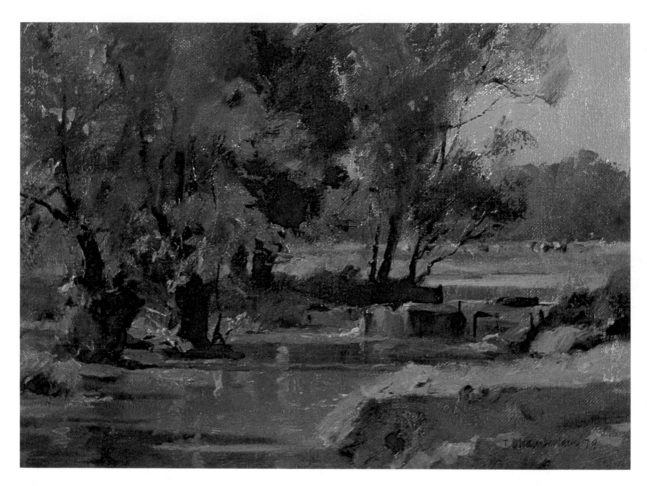

Simplicity, too, is a key element in good composition. Learn to see landscapes in terms of a few large patterns, and, very importantly, don't try to say two things on one canvas. Concentrate on the one thing that attracted you to the scene in the first place and ruthlessly suppress the desire to put in that other attractive feature which you've just noticed. It will only detract from the strength of the first feature.

A little viewfinder made by cutting a rectangle out of a post-card will help you to concentrate on one area and stop you from trying to paint miles and miles of countryside.

Taking this simplicity a stage further, the most common mistake made by beginners is to try and paint too much unimportant detail. For example, they are obsessed by painting the individual leaves and twigs on a tree instead of thinking of it as having

'Summer shadows by the Weir', 10 in × 14 in. Again the same trees as in the Winter Demonstration painted in high summer. Of particular interest was the subtle colour of the water with its shadows.

shape, colour and value. They can't really see the tiny branches on a distant tree but they know the things are there, so they try to paint them in. In other words, they tend to put in what they know about an object instead of what they actually see.

Sometimes the scene in front of you is complete in itself and all you have to do is paint it, but more often than not, you'll have to modify and adapt it slightly to make your picture more satisfactory. Never hesitate to move a tree, or emphasise a curve in a river or leave something out entirely if it detracts from the main purpose of the picture. Too often I've heard the excuse from a student, 'Well, it was there,' when I've queried the point.

'Mellow autumn morning, River Orwell', 16 in × 20 in. This was a beautiful still morning with a hint of sunlight in the distance. Note the nice counterchange at the stern of the barge.

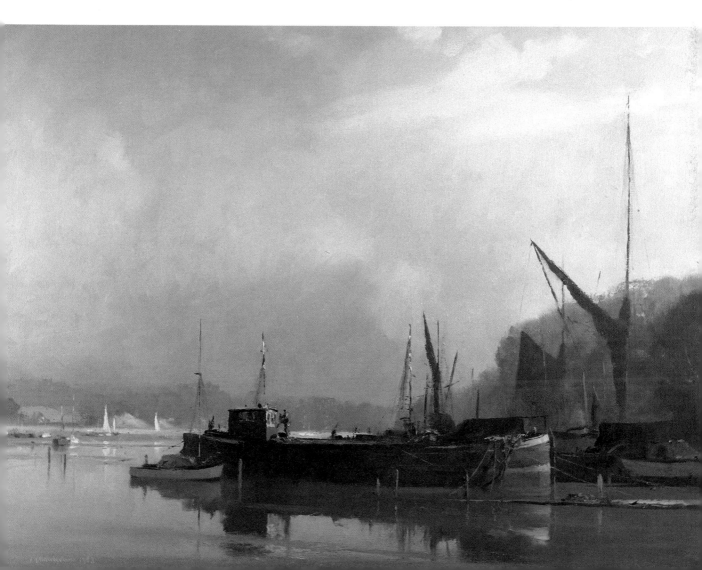

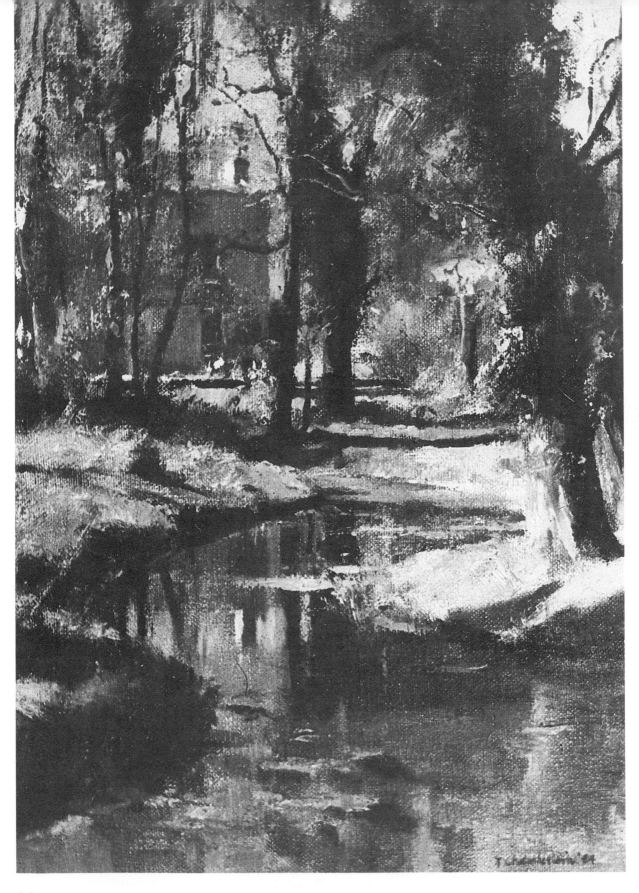

*Opposite*: 'Spring under Molewood', 14 in × 10 in. He went out to try and capture the crisp, spring light with the sun flickering through the trees. The zig-zag stream takes the eye to the distant house, coming to rest at the light patch of garden.

*Below*: 'High summer, Richmond', 8 in × 6 in. This was done with the pochade box, it shows the direct method of painting.

Balance and weight are also important factors in composition. As you distribute the masses within your picture, each one has a definite weight in relation to its size and position on the canvas. If all your objects were on one side of the painting, it would look as if the whole thing was about to tip over, so you have to balance your picture, but never, like a pair of scales, equally on both sides of the canvas as this would make it look very monotonous. Instead, concentrate your main masses on the left or right of the picture and balance them with a small opposite weight.

It's best to avoid 'halves' at all times. Never paint a picture half in the shade and half in the light, or half of it warm in colour and the other half cool.

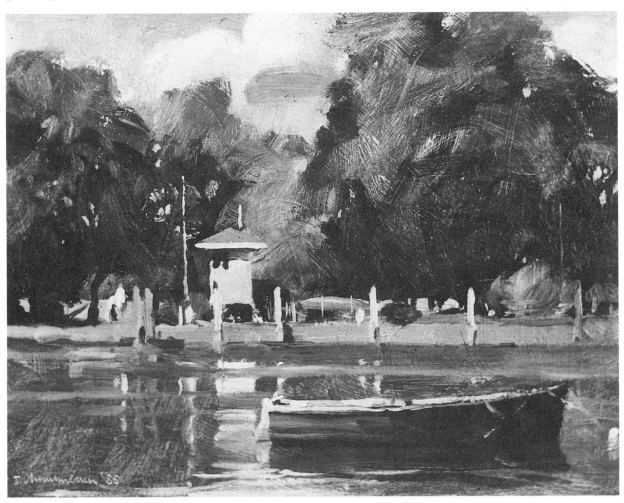

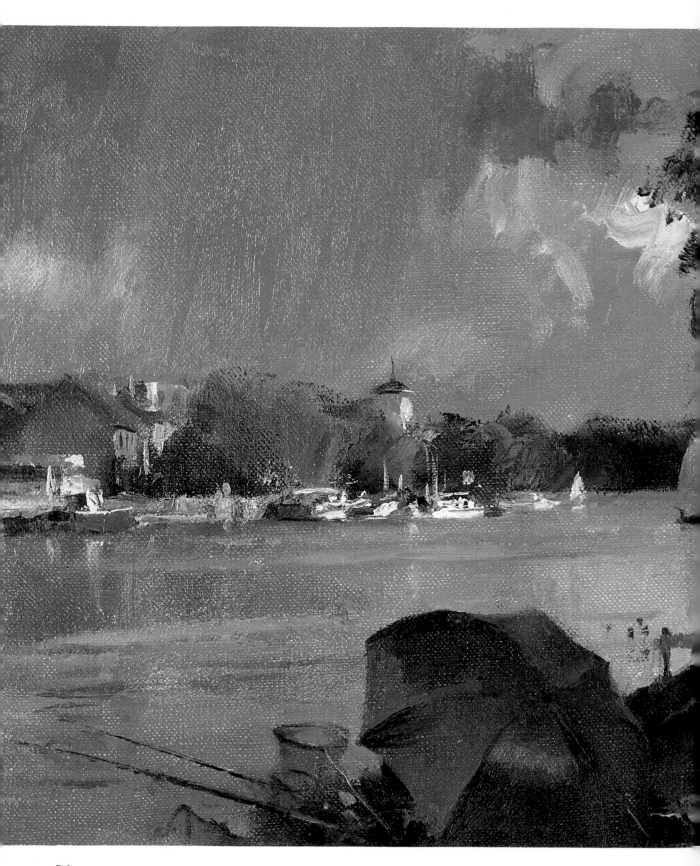

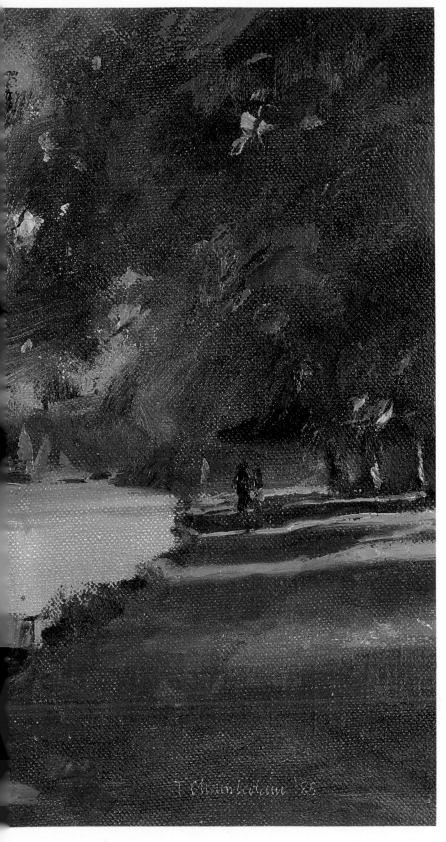

'Passing shower at Kingston-on-Thames', 10 in × 14 in. Painted under fleeting conditions with the sun momentarily lighting up the far bank of the river. The counterchanged fishing umbrella in the foreground helps to give the picture depth.

The worst mistake of all is to put two main objects of equal interest in the painting because the eye tends to bob backwards and forwards between them. Another rule is, never put your horizon exactly in the centre of the picture, as it tends to divide the painting into two equal halves.

Finally, keep plenty of variety in your painting. Contrast softness with crisp, sharp strokes. In a mainly horizontal picture, try to put in at least one vertical object. Vary your textures as much as possible and put plenty of depth in your work. Remember, too, if there's a lot going on in one part of your picture, don't be

*Opposite*: 'Cory's Pier, Woolwich', 14 in × 10 in. Here Trevor liked the very strong vertical interest with the complex effect of the foreground reflections and shadows on the water.

*Below*: 'Watching the tall ships', 14 in × 20 in. This was painted on the Medway while there was a parade of sailing ships.

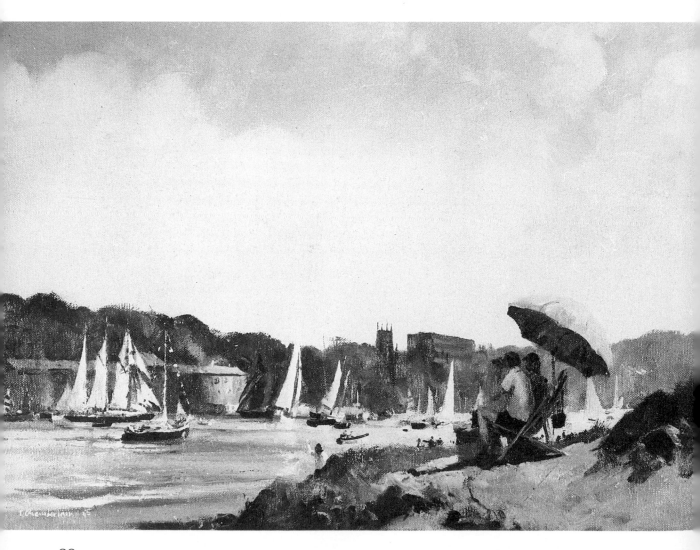

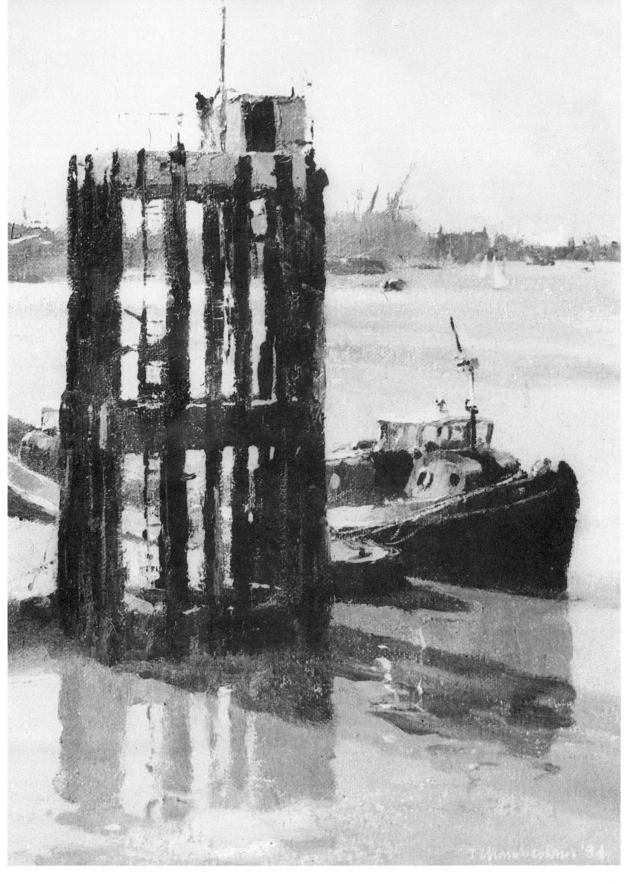

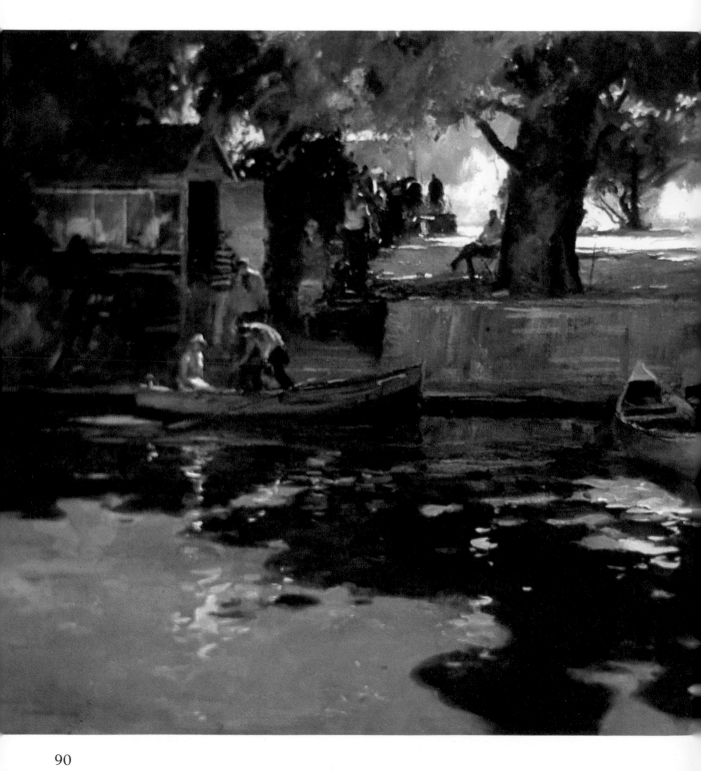

*Above*: 'Young Fisherman', 10 in × 14 in. Painted on the Thames at Teddington, Trevor seized the opportunity of captive sitters, having made sure first that they weren't about to depart home for an hour or so.

afraid to have peace and quiet and even emptiness in other parts. This is something I find students are reluctant to accept; they feel compelled to clutter up a calm field with meaningless strokes because otherwise they think it looks 'too plain'. You can also afford to add a spot of bright colour to an otherwise low-keyed picture.

Aerial perspective, which forms an important part of Trevor's painting, gives an illusion of depth and distance by making the colours greyer as the distance increases. He also diminishes the contrast and, of course reduces the amount of detail. Many artists, including Trevor, often deliberately search out subjects that lend themselves to this technique. Good examples are on pages 42/43, page 73 and the Autumn Demonstration on pages 114/115.

Again, many students seem to be unaware of the technique or forget it as soon as they start painting, putting in very dark trees that are two miles away and leaving no colour in reserve for the foreground trees.

Its always a good rule to paint from the back of a scene to the front – metaphorically whispering in the background and raising your voice in colour and value as you approach the foreground.

*Left*: 'Boats for Hire', 30 in × 40 in. A studio painting taken from a smaller one done on the spot. This subject seemed to have everything going for it. The bright atmosphere of a summer's day, human interest, strong colour and a great range of tones.

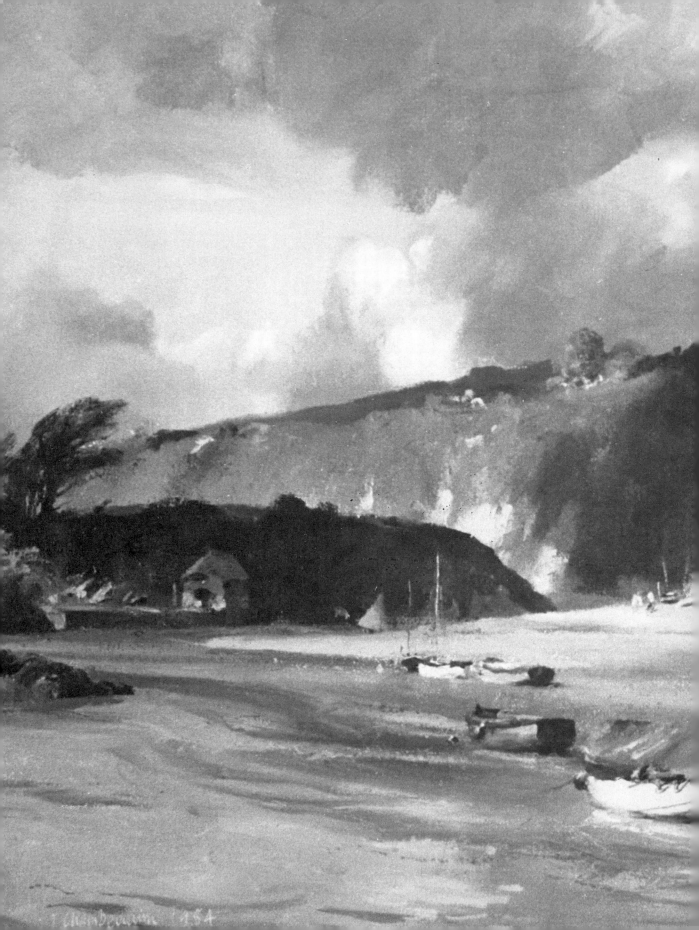

'Rainclouds over the Avon Estuary', 16 in × 20 in. This is one of half a dozen paintings done in that estuary. The striking feature was the great cliff face which seemed to pick up all the cloud shadows as they passed over it, very strong in pattern and counterchange. The figures and the clifftop houses gave it scale and a great feeling of recession. The tree on the left brings the eye back into the picture.

# Summer Demonstration

It was a typical summer's day when the three of us assembled for this painting on the banks of the River Lee near Hertford – cold and wet! However, we had arranged the session days before and two of us had come a long way. So, with me holding up the umbrella over Trevor on the tow-path, we started.

He began by looking through his black view-finder at the subject, adjusting it backwards and forwards until he was satisfied with the arrangement of images within the frame and the centre of interest strategically placed. He sketched it in with charcoal in simple terms, adjusting the positions of the heights and lengths of things to suit his composition, but putting in absolutely no details, just the basic features. With his large brush, he broadly but thinly blocked in the main areas in approximately the correct tone and colour tint, using pigment well thinned down with turps and gel. Then taking up his palette knife he put in the sky

*Above*: Weighing up the subject through the viewfinder.

*Right*: The charcoal drawing. Note the way Trevor has made the foreground boat more elegant and narrower.

in 'buttery' paint, softening and blending the tones with the tip of his finger.

I'm always surprised at how much Trevor uses his fingers in his oil paintings, but it seems to be a very important part of his technique.

Once the sky itself was established, the background trees were painted in and the distant road bridge touched in delicately in grey with the edge of the knife. The large foreground tree was also knifed in. At this point the rain falling on the palette was almost emulsifying the paint, but Trevor carried on undaunted. The patches of light and dark were added to indicate the boats but any real detail was avoided.

One thing I did notice was that he allowed the original underpainting to show through here and there, which seemed to give the painting a subtle richness when it was finished.

*Below*: Laying in the basic tones and colour with very thinned down paint.

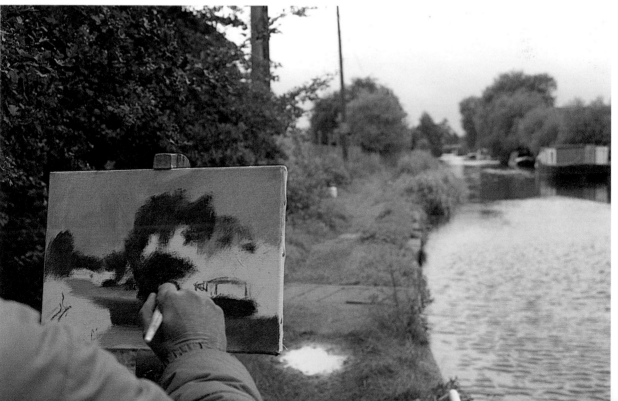

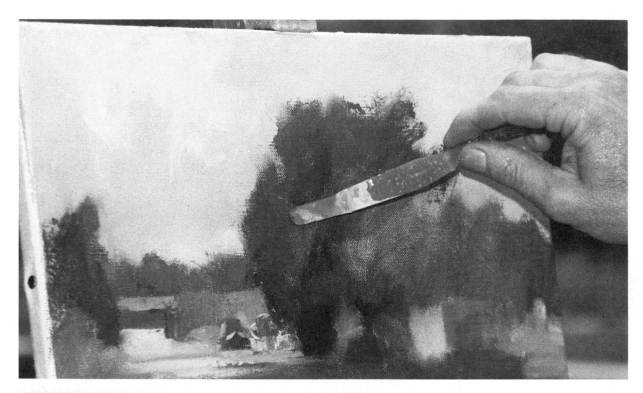

*Above*: Using the flat of the knife to paint in the tree, allowing some of the under-painting to show through.

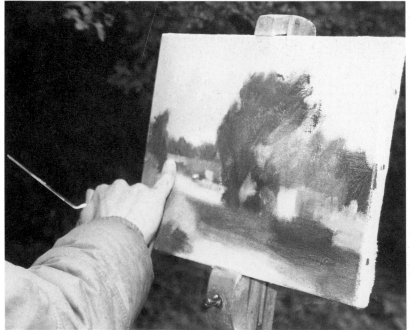

*Left*: Using the finger to soften off an edge.

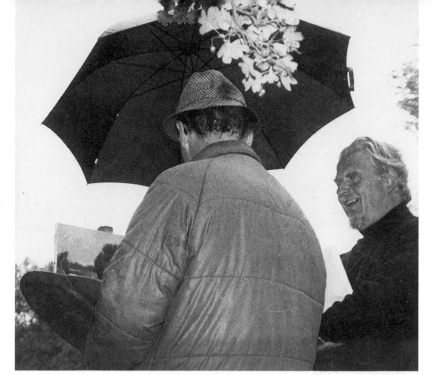

*Right*: Me, as man Friday, holding up the umbrella trying to keep our spirits up in the rain.

*Below*: Using the sable rigger to indicate a few light accents. Don't be tempted by this brush to add too much detail.

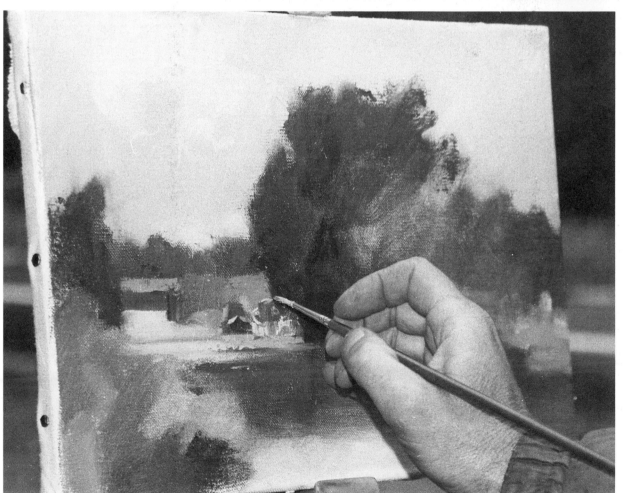

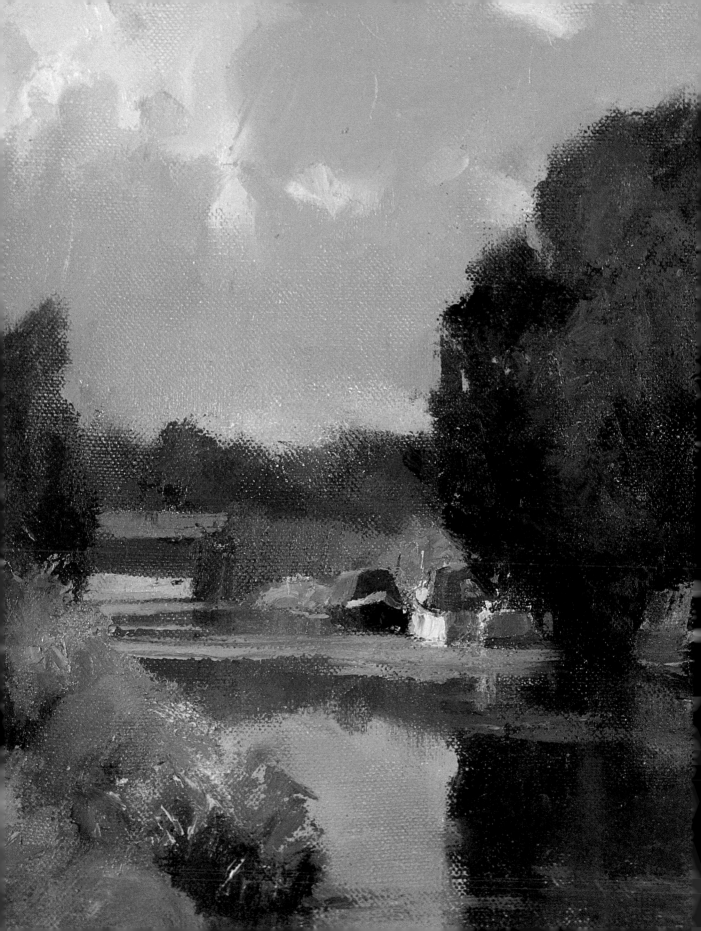

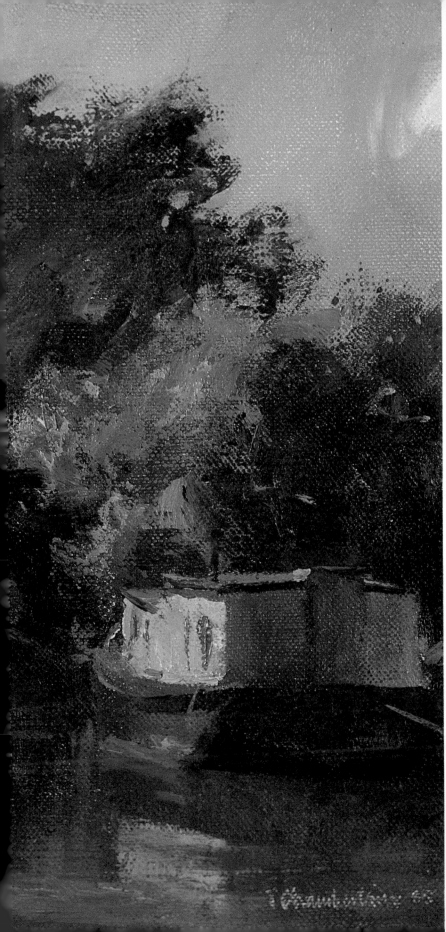

'Houseboats on the Lea'. In spite of the pretty awful conditions Trevor produced a bright, lively painting. The pink on the foreground boat was underpainting which he decided to leave. Note the addition of the foreground figures on the towpath added at the end. Compare it with the original photograph on page 96 to see how the scene has been simplified and adjusted.

# Coastal

For painters like myself, who usually work in the town or countryside, it can be a very chastening experience to be confronted with a seascape, large expanses of open water, skies, and sand, but with very little vegetation. You'll probably find it very difficult, at first, to make an interesting picture out of the few elements at hand, and to convey these vast spaces without making them look monotonous. The idea is to try and portray a feeling of great depth, with enough contrast and interest in the foreground and middleground to give the picture pattern and design.

I think it's better, usually, not to look directly out to sea, but along the shoreline, so that you can emphasise the perspective with something tangible, using all the sparse elements you have available, such as scraps of driftwood, and debris cast up by the tide. To add interest too, you can add boats, figures, seagulls,

'Welsh Cockle Gatherers', 10 in × 14 in. This was painted at low tide, two miles out from the coastline in Barry inlet. A very strong stormy sky seemed to be very close to the ground. It was a very exhilarating experience.

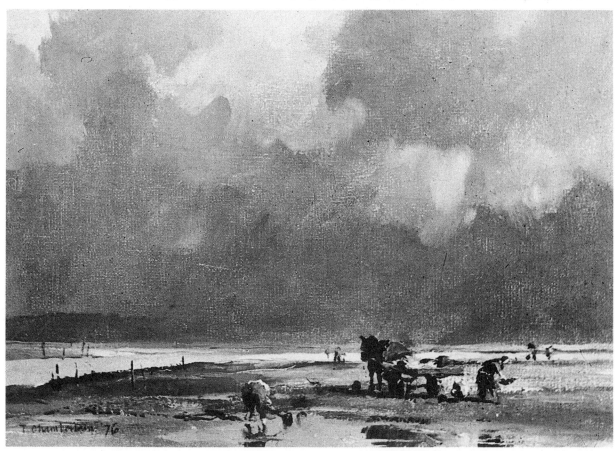

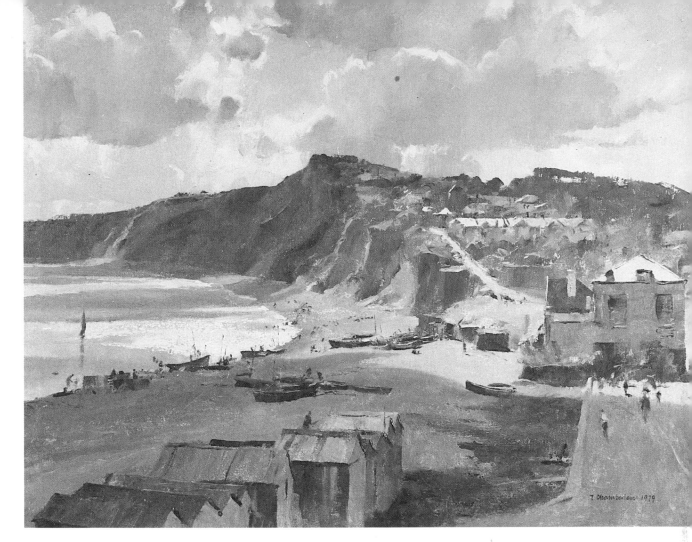

*Above*: 'Summertime, Budleigh Salterton', 24 in × 30 in. This was a studio painting done from a smaller one done on the spot. A very fresh day, with lots of fast-moving cloud shadow and with back lighting shining on the roof tops. There is a feeling of activity set against sharp cliff faces.

*Right*: 'Spring morning, Southwold Promenade', 7 in × 10 in. Trevor was particularly interested in the dazzling seaside light. Notice the centre figures are on the same level as your eye, therefore on the horizon line. The beach figures are below and the figures on the road above your eye line.

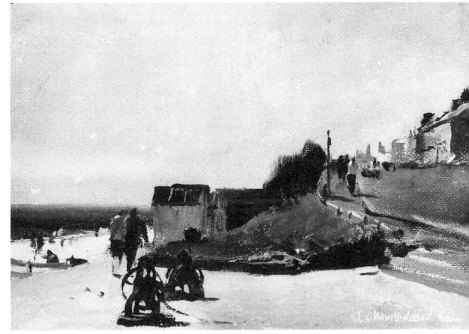

101

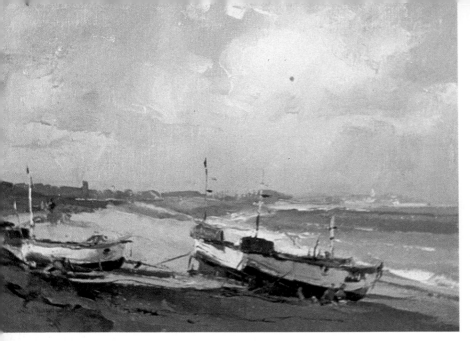

*Above*: 'Northeast Wind, Dunwich Beach', 10 in × 14 in. Here Trevor tried to portray a bright, windy day, he was particularly fascinated by the constant colours of the rough sea. Notice the foreground shadow helping to accentuate the light beach.

water reflections, and passing cloud shadows. You can place your horizon low, and make your sky the main feature, or you could choose a high horizon with attention centred mainly on the features of the beach. However, don't of course, put that horizon dead in the middle, cutting the painting in half.

The actual colour of the sand is important, don't make it too yellow. When it's dry it is really a very light warm grey, but when it's wet it's darker, so you'll usually find it's darker at the water's edge and light on the land side. At low tide some flat parts of the beach will be wet and glistening, reflecting the sky, as well as things next to them, such as boats.

Many student paintings of seascapes fail, because of poor composition, we're back to the picture of two equal rocks or sand dunes, one at each side of the canvas, or the panoramic view of miles of beach, which might look breathtaking when you're actually there, but deadly dull when used as a painting.

Try to avoid trite subjects, such as waves breaking on a rocky shore, which is usually a flop, unless it's done by an absolute expert! Figures can be very important in a beach scene, look at those on page 27, painted with the pochade box, they're put in so

*Right*: 'Anchored off Bradwell, Essex', 14 in × 18 in. There's a vastness of space here, the mysterious light in the distance with a suggestion of things half lost in the mist. The strong foreground gives a foil to the ethereal light above it.

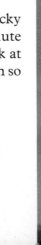

simply, and yet they give such vitality. Note also the counter-change of the dark figure on the left.

Little harbours always seem more interesting and paintable when the tide is out; the boats are tilted on their sides and the exposed harbour bottom, with its fascinating mixture of sand, rock, seaweed and puddles of water, makes good opportunity for reflections, together with the assortment of anchors, ropes and coloured floats.

Maintenance seems to play a disproportionate part in the life of a boat owner. I'm sure I spent a lot more time with a paint-brush in my hand than I ever did with the tiller when I was sailing. However, they make very good subjects for painting when the boats are pulled up on the hard as you can see the whole craft and not just the part above the water line. The keel of a yacht gives a dramatic appearance out of water.

A word about rigging on boats: to most of us this is just a confusion of ropes, especially if you don't know their functions, so it's much better to leave most of it out of your painting, rather than clutter the whole thing up. Just put in the main lines of the rigging very lightly. The usual fault is to put in the ropes too thickly because of lack of brush control, and for boats at a rea-

'Boat and Martello Tower, Hythe', 24 in × 30 in. This was a studio work done from a smaller painting on the spot. There's a strong L-shaped design here. The old towers were built to withstand a possible invasion by Napoleon.

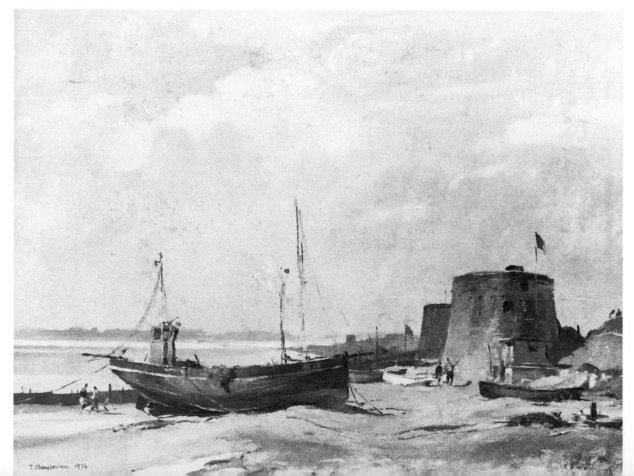

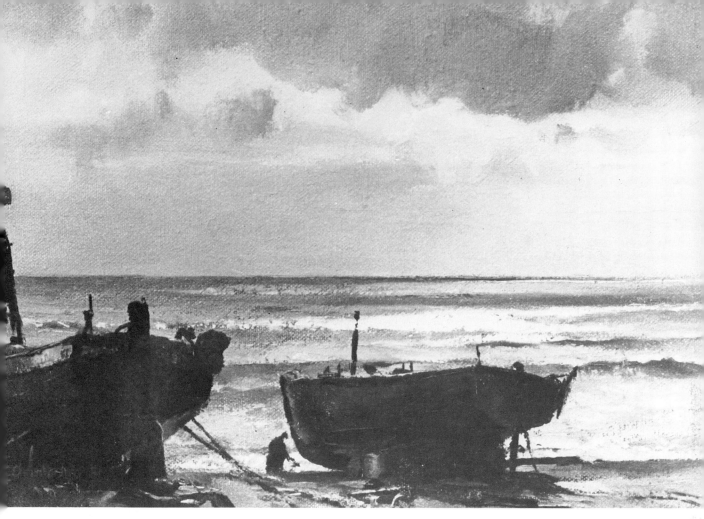

*Above*: 'Bleak North Sea', 10 in × 14 in. Strong silhouettes against the light bouncing off the moving sea. Note the reflected light on the boats to give some form.

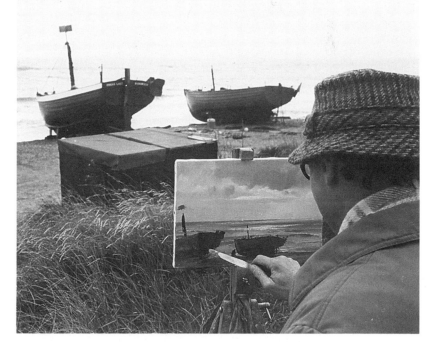

*Right*: A photograph of the work in progress taken by Trevor's late artist companion, Peter Gilman. Note how the sky has been 'dramatised' in the painting.

105

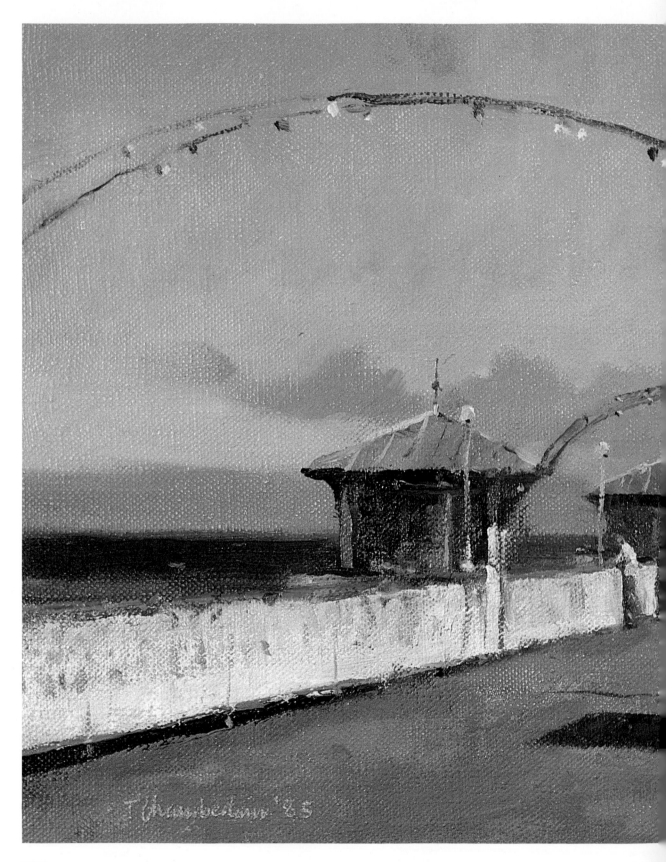

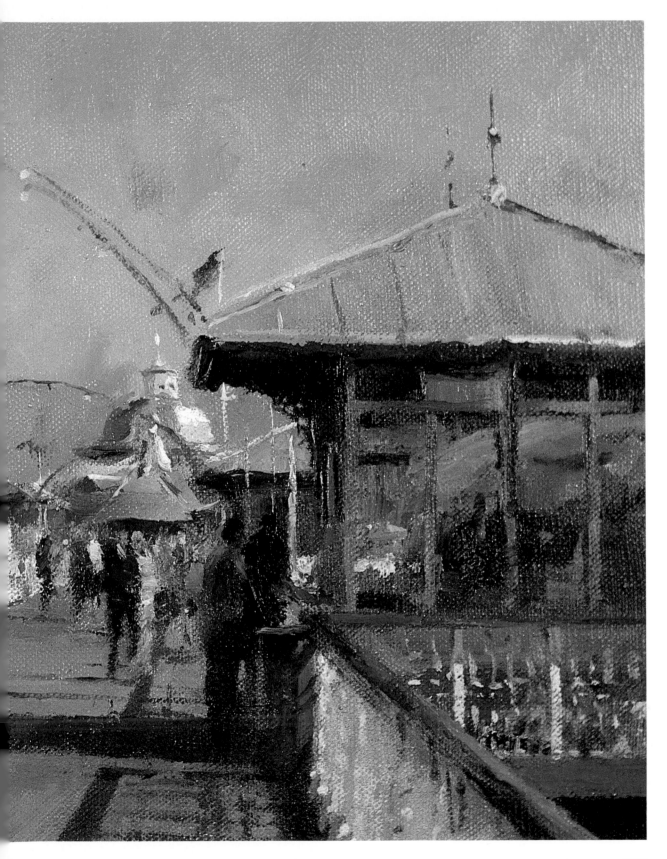

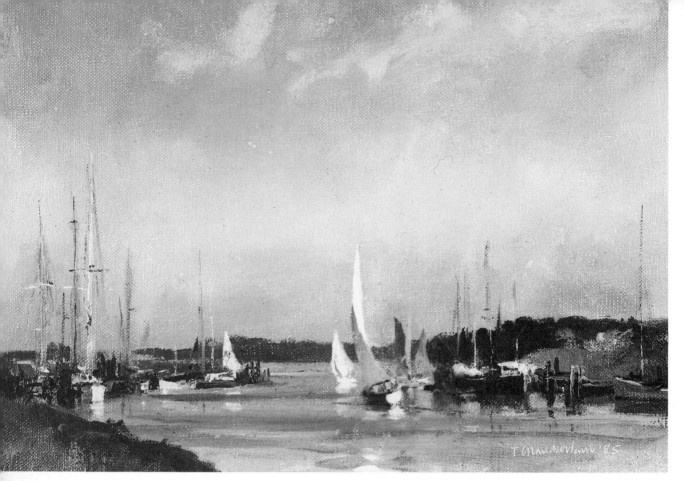

*Above*: 'Sailing, River Blythe', 10 in × 14 in. This depicts a busy estuary with sailing dinghies and moored craft set in a summer landscape. The water is very simply stated with no fussy ripples.

*Previous spread*: 'Crisp Light at Llandudno Pier', 10 in × 14 in. This was a very unusual subject but Trevor was attracted by the pier architecture and the general colour. However, he had to bear the onslaught of hundreds of passers-by! Note the consistent height of the heads on the horizon line no matter how far they are away.

*Left*: 'South Devon Coast', 6 in × 8 in. This is a pochade picture, showing an interesting sky and its influence on the shadowed cliffs. The figures, too, are quite important to the design.

sonable distance away you can forget the rigging lines altogether.

Boat storage and repair yards are marvellous subjects for coastal paintings. You can usually get permission to paint, as long as you keep out of everyone's way! The confusion of gear and general clutter may scare you at first. The answer, of course, is to put everything in very simply. Concentrate on the colour contrast, the counterchange, the large shapes in abstract patterns, and all the varied textures rather than too many superfluous and laborious details.

These yards will also give you an opportunity to put in figures doing all sorts of interesting things, like painting boats, lowering buckets, carrying oars, climbing ladders, or just standing around in groups gossiping! You must learn to put them in simply and directly without any detail. Get the essential movement or silhouette of an action. Just a word on seagulls too. Don't forget that when they're flying around they often overlap each other in a group so don't always draw them as separate birds.

'Edge of sandbank', 7 in × 10 in. The similar location to the painting on page 92. The strong shape of the sand bank leading to the white sail stops the eye going out of the picture. The figures help to give scale.

# Autumn Demonstration

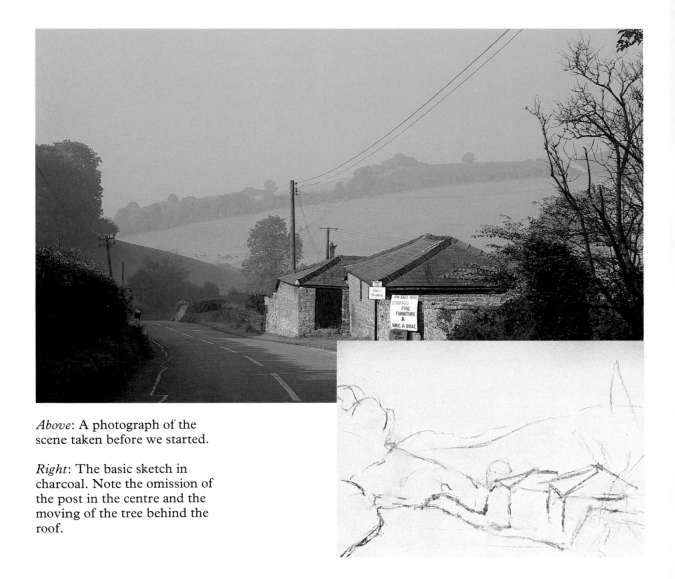

*Above*: A photograph of the scene taken before we started.

*Right*: The basic sketch in charcoal. Note the omission of the post in the centre and the moving of the tree behind the roof.

Trevor and his wife came down to my house in the Wye Valley for a weekend in late September. On the Saturday morning we set out, with the photographer, to find a subject. However, it was too misty down by the river, but as we came up the hill again, the sun was just beginning to filter through. Halfway up, Trevor looked out of the back window of the car and suddenly said, 'That's it'!

I wasn't overly impressed with the subject at first, but analysing it afterwards, I can now see what it was that stopped him.

*Right*: Beginning stages of the broad rough, done with a large brush to establish the tone and general colour.

*Below*: The roughing-in stage completed.

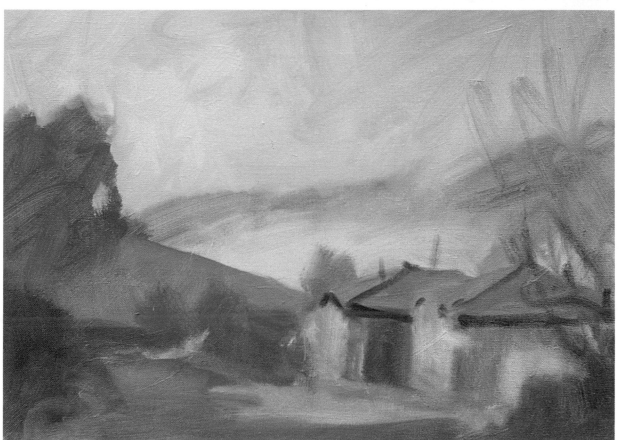

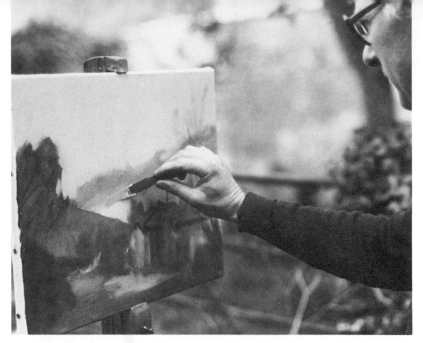

*Left*: Knifing in the areas of colour on the background hills.

*Below left*: Softening off a passage with the fingertip.

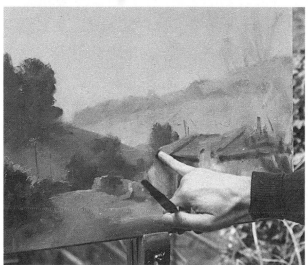 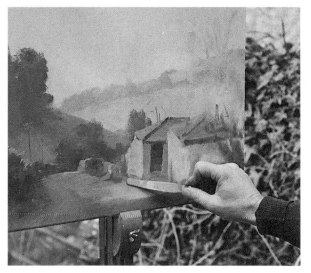

*Above*: Applying the paint with a knife for the grass.

*Left*: Using the sable rigger to depict a window opening.

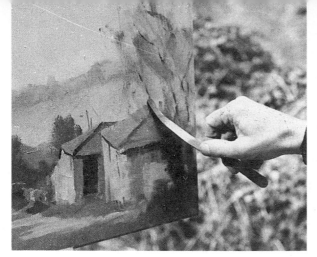
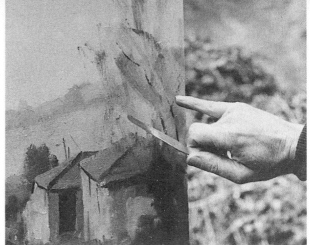

*Above*: Shows bold brushing in of tracery for the tree using the tip of the knife to indicate the branches.

*Above right*: Final softening off of the tracery with the inevitable fingertip!

The scene had great depth with three basic planes. A misty, distant hillside, mid-distance silhouetted trees on the left which balanced the strong sharp foreground of farm buildings. In these there was plenty of opportunity to counterchange and Trevor made the best possible use of them.

Starting from the back, the mid-distance trees counterchange with the light behind them. Coming forward, the distant road and wall are highlighted against the dark trees, as are the roof and wall of the furthest building. The same thing happens with the nearest building which is counterchanged against the dark part of the roof behind it. The lane leads the eye into the picture and the little figure provides a good focal point.

The main areas of the picture Trevor sketched very simply with charcoal; he made sure the roof angles were right, and made corrections now and again with a rag on the end of his finger.

Then came the blocking in, which was done with very much thinned down colour and using a large hog's hair brush, concentrating entirely on the main masses and scrubbed in with wild abandon in about ten minutes, any corrections again being made with the rag-covered finger.

The paint was so thin that it dried almost as quickly as watercolour, so it was possible to repaint the final sky almost immediately, mainly using the knife and softening off the edges with his finger.

After the sky Trevor moved forward through the picture from the distant misty hillside to the trees on the left, then to the building and, finally, the large foreground tree on the right which was scraped in very roughly with the knife and the large brush. I was expecting him to finish it off and strengthen it but he quite rightly understated it so as not to compete with the more detailed buildings behind.

My one and only contribution was to suggest he put in a figure coming up the hill.

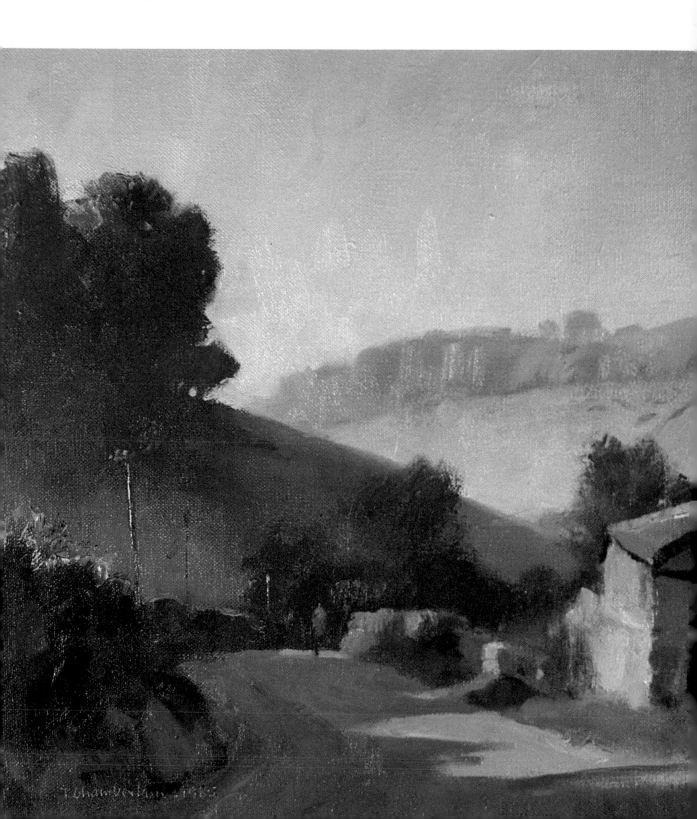

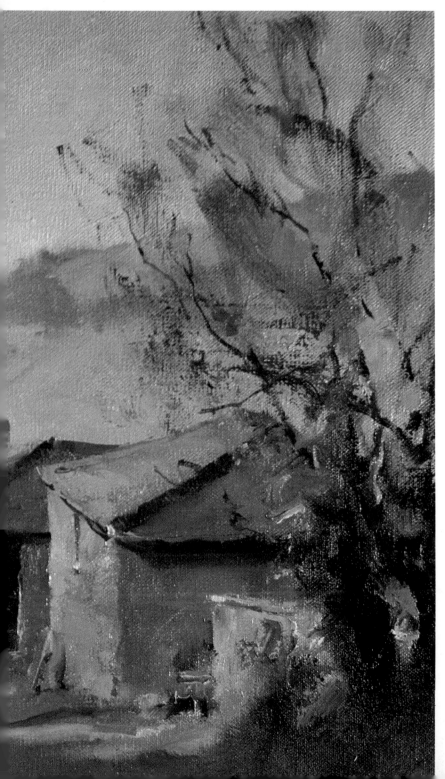

The finished picture. Again, compare this with the photograph of the scene on page 110. See how the subject has been simplified. Note the omission of noticeboards and the centre telegraph pole. Another tree was added to clip the mid-distant hill, there's also much more warmth in the picture. Note how the figure helps to give it life and distance.

# General Landscape

You'll have gathered by now that this isn't the sort of painting book where you're led by the nose through every stage of every painting by 'the Master', and given every colour mix. There are plenty of such books available, though personally I never found these methods very helpful to me, as a student, anyway. No, I'm assuming that you have learned the basic rudiments of your craft, but need a shot of inspiration to fire you with enthusiasm again. From my own experience, I honestly believe the vast majority of leisure oil painters aren't interested, on the whole, in turning out abstract work, but their strong desire is to produce workmanlike and sincere paintings, very much in the manner of the work shown in this book.

The last thing I would want you, as a reader, to do, would be to slavishly emulate Trevor Chamberlain's personal style which has been, in any case, slowly evolved over thirty-five years of painting and observation, but I would like you to try and understand the *raison d'être* behind his work and look at it analytically rather than superficially. For example, study the economy of strokes he uses, not doing more than is absolutely necessary to convey a certain mood and effect.

Studying Trevor's work has also taught me to widen enormously my range of possible subjects from the more conventional ones I had been accepting for years. I'd like to think that in a few weeks *you* might be standing behind your easel commencing a scene you might never have thought of attempting beforehand, saying to yourself, I wonder how Trevor Chamberlain would tackle this?.

Having to earn one's living as a painter, as I do, one is very often tempted to paint an attractive river scene or a mountain range in Scotland, partly because it will stand a good chance of paying the rent. Not so with Trevor. He sees a couple of men clearing up debris in a street, decides he likes the lighting effect on them and comes up with a superb painting. Nor would I have believed a few years ago, that a picture of a man burning rubbish on a beach would hold a position of honour in my lounge but such is the case. It even has a spotlight over it!

Let's go more deeply into the choice of subject matter. Occasionally one is lucky and happens to see a subject in just the right conditions – the atmosphere is crisp and bright, or the lighting particularly mellow or subdued, or the collection of objects seen from a particular viewpoint form a well composed arrangement

'Charcoal burning in Berkshire'.
Trevor was fascinated by the
dramatic effect of billowing
smoke and steam.

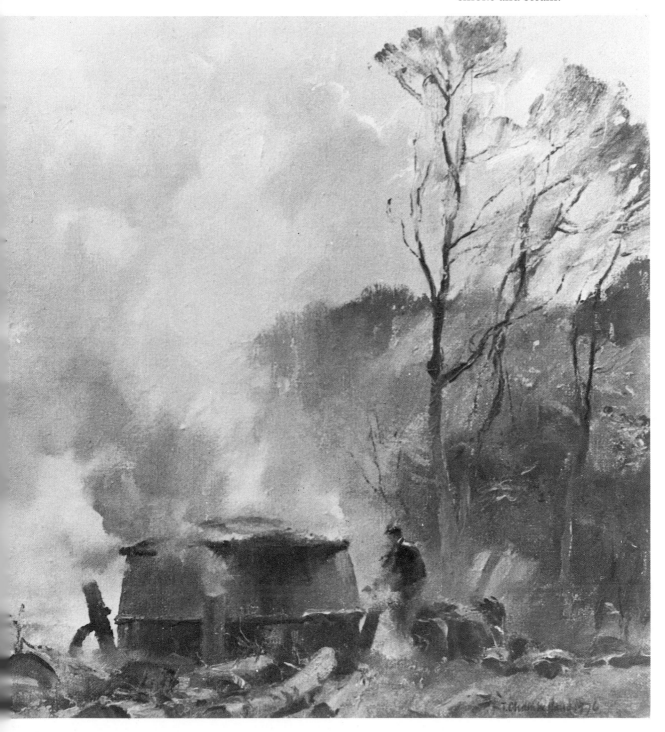

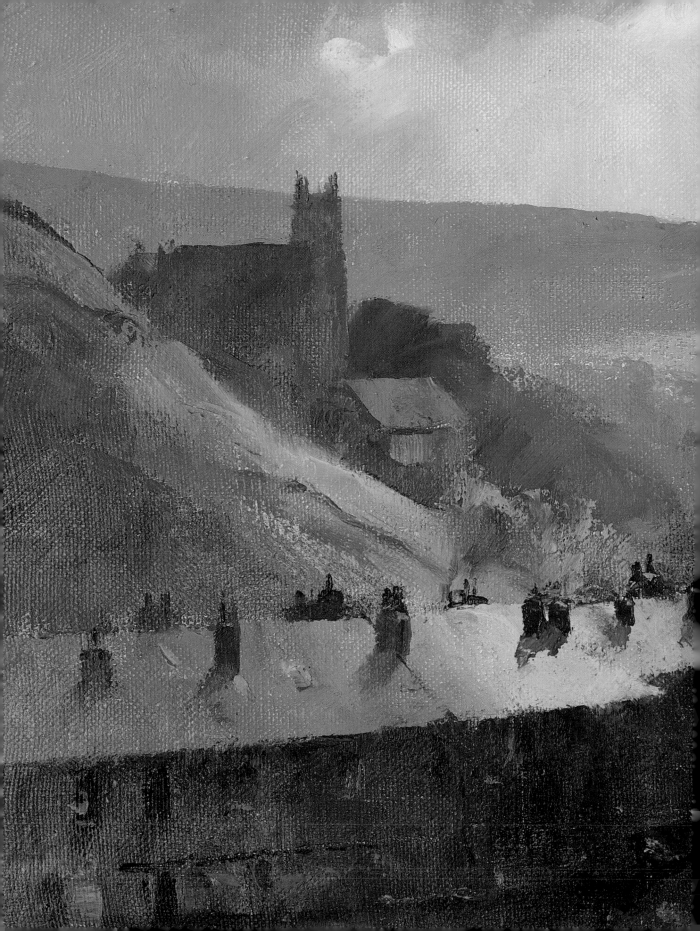

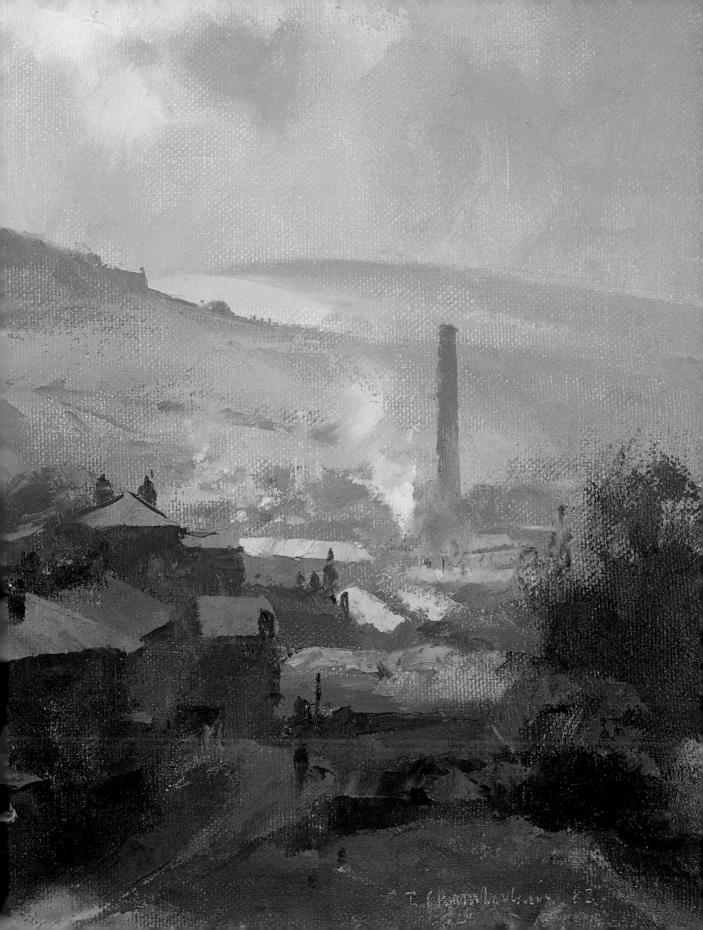

with pleasing shapes. In these circumstances there is no indecision about what to paint, in fact it is sometimes a bit of a scramble to get started, with a feeling of being in the right place at the right time. It's rather frustrating though, if in spotting a subject like this there are reasons why you can't stop and paint, and coming back to it later in the hope of tackling it often proves disappointing. Trevor finds that rising early in the morning can often be the answer. Especially during the spring and autumn, (as well as the benefits of not being bothered by too many onlookers) lighting effects can be remarkable. Everywhere has that fresh bloom for an hour or so.

Even if you can't immediately find a suitable subject, try to avoid scenes which are obviously picturesque, spend a little time just walking around looking at things and becoming familiar with the place. Eventually something appealing will usually emerge. Look for unusual subjects and details, angles, viewpoints, effects, etc. rather than just views. Trevor believes that you can make a picture out of almost any subject matter. Strong sunlight, by the way, is by no means an essential to a good picture, although it does have the advantage of creating shadows and thereby defining form more clearly. On dull days though, he

*Above*: 'Welsh mountain sheep', 10 in × 14 in. He liked the strong images in this scene, the zig-zag design and the low cloud linked with the mountain which seemed to hover there indefinitely.

*Previous spread*: 'A Lancashire valley', 10 in × 14 in. Painted from the hills overlooking a town near Rochdale. There's a strong design here of sunlit roofs sweeping into the picture, leading the eye to the chimney and smoke. A church tower could have presented a conflicting interest but was deliberately played down in treatment; the tower was slightly raised to break the line of the hillside.

120

'Summer evening, edge of the Meads', 6 in × 8 in. There were tonal steps into the distance with the counterchanged house giving a nice accent. Very satisfactory design.

finds that by choosing a 'watery' subject, more contrasts can be created by the prevailing light being reflected off the water.

When you've made your choice, never lose sight of what originally 'turned you on' about it, and make this the most important part of your painting. The emotional response should always come first. A painting is often more exciting than nature because it is a distillation of it. It stresses the poetry of the scene and should be a frank expression of your feelings towards it.

Having been closely associated with the collection of Trevor's paintings over some months, as I have produced this book, I've begun to understand his thinking and to see, as it were, the visual common denominator. The actual subject matter is not so important to him, so much as the atmosphere and light effect created by it. I could quite imagine him painting a council rubbish tip, providing it was done at dawn, and he could counter-

change the inevitable seagulls against the rising smoke. He'd put up with the smell 'on site' for a couple of hours, and end up by winning an award for it too! If you study his paintings as closely as I have done, I'm sure you'll find yourself looking for possible subject matter for your own pictures, in a completely different and more exciting way.

Regarding your mental attitude to your paintings, good judgement, and a healthy self-criticism are absolutely necessary for your continual progess as a painter. But self-criticism, like any other form of criticism, has to be balanced – self-recrimination is often a continual state of mind for many students, they say something bad about their work no matter how successful it is. When a painting really comes off, give yourself a pat on the back – you deserve it.

'Flock of sheep', 7 in × 10 in. Trevor just felt like painting sheep that day. Nice L-shaped design. Note how the shadow in the right hand foreground keeps the eye in the picture.

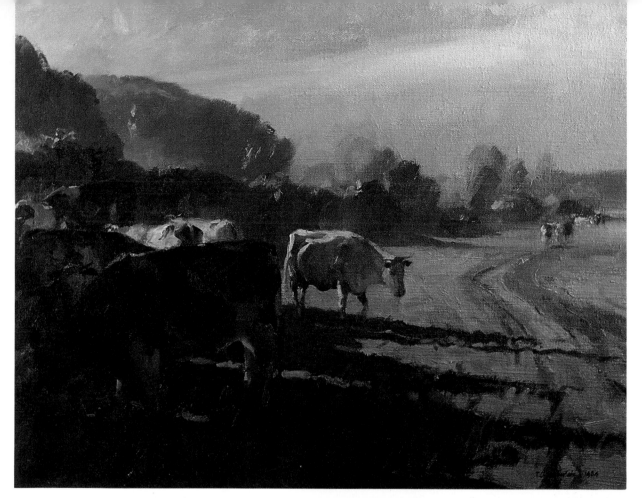

*Above*: 'October meadow, morning', 20 in × 24 in. Trevor set out that morning without any thoughts and came upon these cows. They kept moving but came back again. Strong foreground shadows attracted him with the sunlit distance.

*Right*: 'Billowing sky over Ely', 14 in × 10 in. Trevor tried to show the sheer towering mass of Ely Cathedral West Tower above the surrounding town by the scale of the figures and cars, etc. Note how he's set the head of the tower against a huge white cloud.

*Above*: 'Guy Fawkes Night, Ware', 18 in × 22 in. Painted from memory the day after he had a terrific impression of the event with its enormous bonfire and lighting effects.

When you know you're in trouble with a painting, try to find a solution to it, don't just give up in despair. We've all gone through those hours of self-recrimination after a bit of a flop, when we truly believe that we'll never make an artist, but do try to get out of this sterile, negative state. The attitude should be to find out what's wrong and correct it. Another thing that holds up so many of my own students, is a fear of failure, they put off starting a picture by all sorts of self-deception, such as finding seemingly more important things to do, rather than put that first blob of paint on the virgin canvas. Learn to recognise this self-deception in yourself, and devise ways of overcoming it.

An experienced painter is the product of many different influences derived from the work of other artists he or she has admired and, perhaps, emulated before a personal style is finally evolved.

One can even follow the influence of different artists on Picasso's work in his early periods. My own work has been greatly affected by the French Impressionists. Their pictures always attract me like a magnet, whenever I'm near a London Gallery. But as I mentioned in the introduction, the strongest influence on me, by far, has been the work of Edward Seago, who died in 1974. Born in Norfolk, he painted in both water-colour and oils. The trouble is that most of the books of collections of his work are now out of print and are like gold dust. I've tried unsuccessfully to find two such books for years. However,

*Right*: 'The Farm at Sandridge', 24 in × 30 in. Studio painting from an oil done on the spot. Strong back lighting on the subjects accentuated the shapes and contrasts of the lights and darks. This handsome old barn was demolished shortly after he painted it.

*Below*: 'Showers at Aldeburgh', 24 in × 30 in. Studio painting from a smaller one done on the spot. He tried to capture the essence of a grey day, with sunlight, wet roads and heavy sky leading to a contrasting sunlit tower in the distance.

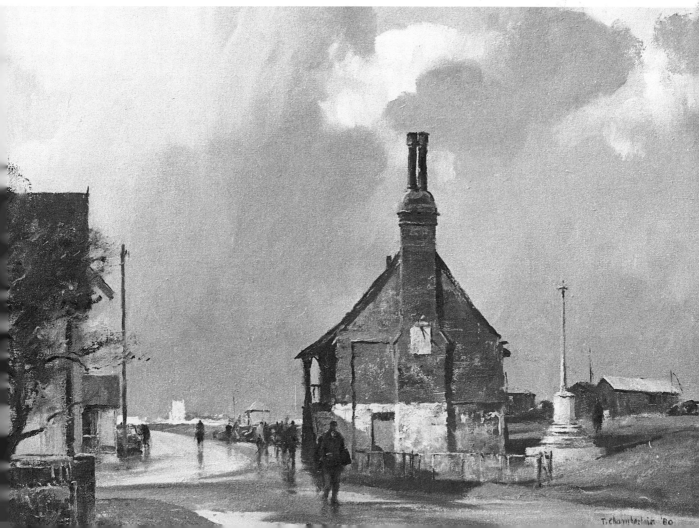

one can obtain catalogues of his various past exhibitions which contain beautiful colour reproductions of his pictures, by writing to the Marlborough Gallery in London.

One final word, when you're painting on the spot, try for mood rather than detail. This calls for rapid execution if you want to capture your chosen effect. You must work with all the speed you're capable of, because sunlight and shadows don't stand still and what may have excited you when you started painting might look very ordinary a couple of hours later. Trevor Chamberlain and I are completely different characters and normally paint in different mediums, our common link is that we both in our own ways try to paint an impression. I hope that our combined efforts in this book have given you food for thought.

*Below*: 'Showers – Lea Valley', 16 in × 20 in. A very interesting sky with rainclouds. The main centre of interest is the white cottage counterchanged against the dark woods.

*Right*: 'April raincloud over Wear Park', 10 in × 14 in. This is really a skyscape, plenty of drama set off by the sunlit buildings in the distance. The shadows contribute to the design of the picture.

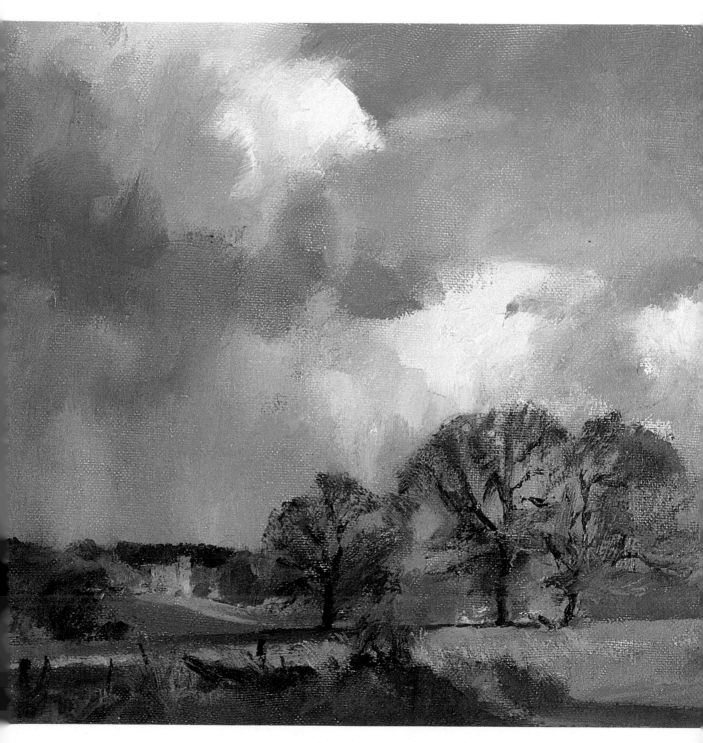

# Index